JAPANESE ALPHABET

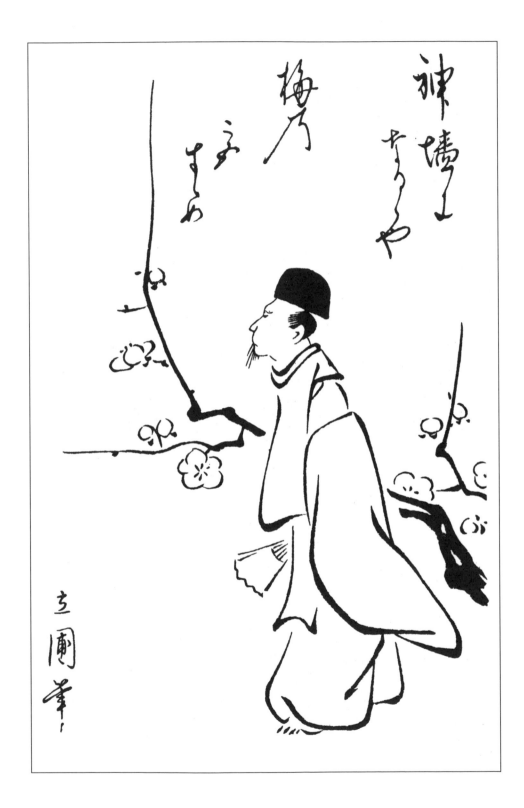

GABRIELE MANDEL

JAPANESE

the 48 essential characters

ALPHABET

FOREWORD BY ISAO HOSOE

ABBEVILLE PRESS

NEW YORK LONDON

Page 2:
The "minister of right" Sugawara no Michizane (AD 845–903) contemplating flowering plum-trees in a drawing by Ritsuo taken from the *Wakan meigwa yen*.

Art Director: Giorgio Seppi
Managing Editor: Lidia Maurizi
Graphic Designer: Chiara Forte
Editor: Giacomo Ambrosi, AGMedia s.r.l., Milan
Layout: Massimo DeCarli, AGMedia s.r.l., Milan

For the English-language edition:
Translator: Jay Hyams
Typesetter: William Schultz
Production Editor: Megan Malta
Production Manager: Louise Kurtz
Jacket Design: Misha Beletsky

First published in Italy in 2007 by Mondadori Electa S.p.A., Milan.

First published in the United States of America in 2008 by Abbeville Press Publishers, 137 Varick Street, New York, NY 10013.

10 9 8 7 6 5 4 3 2 1

©2007 Mondadori Electa S.p.A., Milan
English Translation ©2007 Mondadori Electa S.p.A., Milan
All rights reserved

ISBN 978-0-7892-0959-7

Printed and bound in Spain.

For bulk and premium sales and for text adoption procedures, write to Customer Service Manager, Abbeville Press, 137 Varick Street, New York, NY 10013 or call 1-800-Artbook.

Library of Congress cataloging-in-publication data is available upon request.

Visit Abbeville Press online at www.abbeville.com

CONTENTS

FOREWORD

East-thetics. *After moving to Italy, I experienced a sense of delight mixed with a tinge of dismay each time a letter arrived from my mother in Japan. The dismay resulted from the certainty that I would find myself unable to understand all of what she had written. My mother used* sosho-tai *writing, a variant of* hiragana *(the writing of women and poetry) instead of the simpler* katakana *(men's writing, used in bureaucratic and government communications as well as for foreign words). The term* sosho-tai *means "grass writing" and refers to the characteristic flourishes of this style, which seems vaguely related to the Art Nouveau style of the West. Although unable to completely understand my mother's writing—something I would never have confessed to her—I knew I nonetheless would be able to grasp its intimate essence, its flavor, and thus its meaning, if not the hidden shadings and sentiments.*

I believe that simple anecdote captures the profound nature of both the writing and the identity of Japan. I could very well conclude my foreword right here, leaving the reader with the choice of either reflecting upon or immediately dismissing this foreword and moving on directly to the beginning of this fascinating book. On the other hand, it seems only right to add some element that might prove useful to the comprehension of the "flavor" of Japanese culture without going into detail on the development of Japan's writing, a subject presented in an illuminating way by Professor Mandel. I will seek here instead to delineate the context or framework in which that writing came into being.

First I must say that the history of Japanese writing coincides with the history of Japanese culture. Borrowing *and* differentiation *are two key words that can make this development easier to understand. The ideographic basis of Japanese writing is derived from Chinese, which, like many other loans, proved decisive in the formation of the Japanese identity. Of course, it is never easy to identify and precisely define how much is owed to a given loan, but to disregard or even deny its existence would be to ignore the very foundations of originality. Japan has always grafted its own vision onto its "imported" foundation, not treating the object as an extraneous body but filtering it through the new context, causing it to be reborn in a way. This is what happened with writing, with Zen culture—which after traversing India and China, reached maturity in Japan—or in more recent times with the refinement of a variety of new technologies: the Walkman, to name*

only one. One of the most striking elements of Japanese writing is the absence of the development of an alphabetic system free of the ideograms, a fact that casts light on the Japanese tendency toward a continuity with the past. This now permits the introduction of a third word: memory. *There is a big difference between ideographic sign and alphabetic letter, most of all from the point of view of the mnemonic exercise. At the end of World War II there was a proposal to abolish the ideographic system, which had been accused of being complicated and irrational, and subconsciously considered partially to blame for the military defeat. Shiga Naoya, one of Japan's greatest writers, advanced the idea of replacing Japanese with French, a proposal that fortunately did not go very far. The importance of memory and its role become clear by referring to the Buddhist conception of the senses, according to which the eighth and final sense is called* Alaya-Shiki, *best translated as "storehouse of the senses." It is a sort of total and primal depository in the same way that* Hima-Alaya *(the mountain system) means "storehouse of the snow." Stored in the* Alaya-Shiki *are all the previous incarnations of each individual, with all stages of phylogenesis, including the one in which the living being was a cell and earlier still a molecule, an atom, an energy quantum. Access to this quantity of memory, to this wealth of data, evokes the problem of the direction of the information, a problem very similar to the relationship that each person maintains with the modalities of contemporary society, the so-called postmodern society, characterized by a high level of complexity and chaos. In this regard I believe it is useful to refer to a certain "culture of fluidity" that came to life at more or less the same time 2,500 years ago in three different places: China, Greece, and India. Lao-tze, a contemporary of Confucius, elaborated the fundamental concept of Taoism, the law of disorder in contrast to Confucius's law of order. Lao-tze also discovered the importance of emptiness to movement, the emptiness in which life must take place. Heraclitus, the Greek philosopher of Ephesus to whom we owe the concept that "everything flows" (eternal flux), taught that permanence was an illusion, that the world was in eternal movement and continuous transformation. Then there is Buddha, who even on his deathbed reaffirmed that nothing can last eternally, leaving us with a great instrument for understanding the world, one that even today could help us to pass our brief lives in a joyful way. The teachings of these masters would seem to have been forgotten by modern culture, a culture in which human intelligence, in the words of the French philosopher Henri Bergson, "is never entirely at home, except when it is working upon inert matter, more particularly upon solids . . . our logic is the logic of solids . . . our intelligence triumphs in geometry." All this despite the advent and widespread diffusion of scenarios of chaos—such as*

the Internet—and despite new and fruitful mixtures of the various sciences. In the words of Lewis Mumford: "Power, speed, motion, standardization, mass production, quantification, discipline, precision, uniformity, astronomical regularity, control, most of all control, have become the key words in the new Western-style modern society."

As far as humans and their relationship with objects is concerned, useful indications can be found (in terms of memory) by retracing the experiences of nomadic hunters, the way humans lived for 200,000 years, a period twenty times longer than the succeeding agricultural period and a thousand times longer than the Homo faber period, or industrial civilization. For two thousand centuries— and still today in a few minor residual anthropological niches—nomads lived on the move, using what they needed without putting down roots, conserving only the bare minimum, perceiving themselves as an event of the world without imposing any kind of order on it. In short, humans made use of things through behavioral energy instead of destroying them and imprisoning the energy of matter. Thus behavior becomes another key word. This is a theme I feel very strongly about and that often shows up in my activity as a designer, in which it has led me to develop the concept of "behavioral energy" and to discover how, to my way of seeing, the primary goal of design must be a "behavior" and not a "product."

In conclusion, for the first time in this foreword, I will use the word aesthetic. It is a word often associated with Japan, quite often out of place. Japanese culture is certainly pervaded by an aesthetic form; this form, however, cannot be explained, as is often done in the West, by contrasting it with the category of the functional. The aesthetic I'm talking about can be recognized, one might say, by its "flavor." For example, when they set about transcribing the Buddhist sutras, the monks used the system of scrolls. Scrolls involve a self-supporting system of writing, meaning there is no need for a desk or other support. It functions like this: the rolled scroll is held lightly in the left hand while the writing is done with the right, along the spine of the page, the narrow surface made rigid by the tubular shape. To continue writing, one simply rolls the page of the scroll until the narrow surface is again blank.

This is the reason Japan developed a writing style with a vertical form, aligned on the left. It is a type of writing that involves highly precise gestures, and thus a certain behavior. We can imagine the recipient of a letter, let's say a love letter, who in a shadowy room slowly unrolls the text, column by column, until the point is reached at which the scroll, completely unrolled, lets its message appear in its totality. In this gestural sensibility, in the totality of the messages that it delivers, in the desire to go beyond the mere contents of the text, one finds the "flavor" of Japanese culture.

Professor Mandel, with his ability to move so skillfully through Japanese writing (as he has already done with Arabic) shows himself to be gifted with a shamanistic nature. Like the mythical dragon that lived in the valley of the Indus River, he soars rapidly skyward, invisible to all humans, to collect inspiration and ideas to bring back to earth. The descent to earth is always the most creative and delicate part of the procedure. In fact, along the route of its descent, as though it were a calligraphy brush (another art of which Professor Mandel is a master), the dragon leaves his message in the sky in a perfect sosho-tai style that is visible for an instant to all those who are able to interpret it.

Ah, I almost forgot. It is said that ethics, the philosophy of morals, the investigation and reflection on the active behavior of humans, when it arrived in the East became East-thetics . . . aesthetics.

Isao Hosoe*

* Born in Tokyo in 1942, Isao Hosoe got a degree in aerospace engineering from Nihon University in 1965. In 1967 he moved to Milan, where he founded Isao Hosoe Design in 1985. He teaches industrial design at the Milan Polyclinic and at the University of Rome. He is a visiting professor in several institutes outside Italy. He has won numerous international prizes for his works in the fields of industrial design, transportation, and telecommunications. His works appear in the Victoria and Albert Museum in London and in the Metropolitan Museum of Art in New York.

ガブリエル・マシデル・バコニン

カタカナ

ひらかな

INTRODUCTION

Origins and development of Chinese writing

Humanity has always been dominated by symbols. A word is a symbol, and every writing system involves symbols. Concepts—from the simple to the complex—are symbols, as are all the signs, actions, and rites that compose the tangible manifestations of reality and its abstract essence. For some populations a certain category of symbols, writing, is not only the systematic presentation of oral sounds but is also an artistic expression with a spiritual value that extends beyond the phonemes expressed to achieve artistic-emblematic values fully perceptible by those who have been instructed in these refined and sensitive arts.

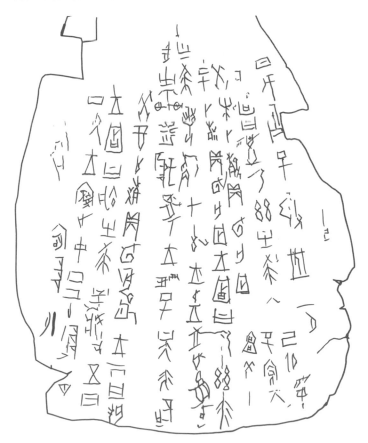

Opposite: Graphic elaboration with letters from the *hiragana* and *katakana* alphabets.

Left: The characters of an oracular inscription (*jiaguwen*) inscribed on a turtle-shell, from the period of the Shang dynasty (seventeenth century BC to 1050–25 BC). Research Institute for Humanistic Studies, University of Tokyo.

The Japanese writing system is one of these, and it is considered special and unique because it unites two different cultures (the Chinese and the Japanese) and two methods of writing in clear opposition to each other: the ideographic and the alphabetic. It has been established that Japan's two phonetic alphabets originated from Chinese pictograms. It is also true that these alphabets were not often used on their own and instead were usually used together with Chinese ideograms that were read, however, in the Japanese language. It is thus necessary to first analyze Chinese writing and to trace its history. Only then can we turn to the study of Japan during the great epochs and experience the adventure of its alphabets as an exciting and unique historical event, blending art forms, religious culture, and mystical aspirations. Most of all, we must remember that for both the Chinese and the Japanese cultures the long tradition of writing was understood primarily as a spiritual art, a *do*: a means of achieving self-discovery and individual perfection.

The pictograph system (drawing a picture of an object rather than expressing it in alphabetic symbols) is doubtless the oldest writing system for many cultures. It was most probably based on symbols dating to the Paleolithic period that were later codified

Chinese ritual bronzeware from Henan. The table reads from top to bottom, giving the shape of the vessel, the first Chinese character used to write its name, the current Chinese character, and the romanization of the Chinese character.

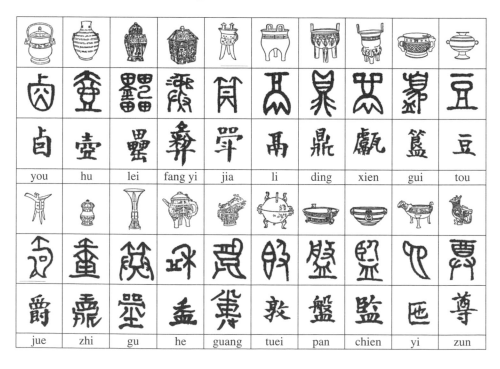

| you | hu | lei | fang yi | jia | li | ding | xien | gui | tou |

| jue | zhi | gu | he | guang | tuei | pan | chien | yi | zun |

Jinwen characters from the period of the Jin dynasties (AD 265–420).

in a more refined way during that part of the Neolithic period in which human beings represented objects and animals figuratively, before evolving to the later abstract-symbolic phase. Thus we must go back at least thirty thousand years. The pictographic system dates back to at least 3200 BC in various cultures; in Egypt, which by that time had developed a monarchic state; in Mesopotamia, among the Sumerians, a people perhaps of the Mongoloid race; in the pre-Columbian culture, although the dating there is uncertain because of the destruction carried out by the *conquistadores*; and, of course, in China. In China, beautiful writing, which originated from the perfect delineation of the painted object, was associated with a sense of art and with literary expression, leading to a calligraphic art emblematic of China's great culture.

Pictograms depicted objects, and ideograms represented ideas and concepts; the fusion of the two methods of writing led to *semantemes*, the linguistic word for basic units of meaning. The oldest known semantemes (called *jiaguwen*; in Japanese, *kokotsubun*)—a relatively evolved form of hieroglyphics—date to the second half of the Shang dynasty (from the seventeenth century BC to 1050–25 BC), by which time they were already well-formulated, indicating they were derived from even older forms, unknown and untraceable. With the passage of time, the *jiaguwen* phonemes came to be read as sounds and were no longer merely depictions of objects. As such they were the basis for the ideographic characters of the two Han dynasties (206 BC–AD 220), on which the ideograms still in use today were based.

The earliest surviving *jiaguwen* are divinations inscribed on turtleshells and ox bones (thus known as oracle-bone script) that were discovered near the end of the nineteenth century in the northern Henan province at Anyang, site of the ancient capital of the Shang dynasty from 1300 to 1028 BC. Also found on this site were splendid ritual bronzes (first phase: 1300–900 BC; second phase: 900–600 BC), all of which bear—engraved or as part of the cast vessel—texts written using a few characters (about two hundred graphemes). These are dedicatory texts, and they present an already well evolved form. Without doubt, some of these graphemes were being read for their figurative value and others for their phonetic value.

In the evolved ideographic writing system, each individual grapheme can be "read" in various ways or "values": as a pictogram, ideogram, semanteme, phoneme, but also by way of a variety of mixtures and different uses of these values. Thus the first group of Chinese graphemes evolved into the later, increasingly codified characters known as the *liu-shu* ("six scripts"). Every one of these

The phrase *Wan pang husn ning* ("Many nations have laid down their arms") in various characters:
1. oracle bones (*jiaguwen*);
2. on bronzes (*jinwen*);
3. small seal script (*xiao zhuan*);
4. clerical script (*lishu*);
5. standard script (*kaishu*);
6. semicursive script (*xingshu*);
7. cursive script, erroneously called grass script (*caoshu*). In Japanese, from 2 to 7, these styles are called *kinbun, shoten, reisho, kaisho, gyosho, sosho.*

1				
2				
3				
4				
5				
6				
7				

characters includes three elements: form, sound, and meaning. According to their individual pictographic or ideographic values, these six scripts or categories are 1) *hsiang* (or *hsiang hsing*): pictographic representation; 2) *chih shih*: ideographic renderings of abstract ideas; 3) *hui yi* (indicatives): combinations of characters based on associations of ideas; 4) *chuan chu* (deflection and inversion): indications by generalized analogy; 5) *chia chieh* (loan references): a character used for its phonetic value to represent a homophone with a different meaning; 6) *hsing sheng*: composites of phonetic characters with pictorial elements, usually 7,697 in all, that constitute the most important class of Chinese writing.

The characters used in oracle-bone inscriptions were soon being used in dedicatory inscriptions on ritual bronzeware (*jinwen*, "script on metal"), numerous examples of which survive dating to the period of the Western Zhou (c. 1050–771 BC). The characters were evolving rapidly during this period and gave origin to two types of classical writing, the *jinwen* of the Eastern Zhou (770–256 BC) and the *jinwen* of the *Spring and Autumn Annals* (722–481 BC). So-called seal script also came into existence (*zhuanshu*; in Japanese, *tensho*), divided into small scal script (*xiao zhuan*; in Japanese, *shoten*) and large seal script (*da zhuan*; in Japanese *daiten*), written on strips of bamboo strung together side by side. These were first inscribed and then (475–221 BC) painted using a brush composed of goat or rabbit hairs fixed to the end of a bamboo holder. During the same period the custom began or writing on fabrics, in particular silk.

In 221 BC, China's first emperor, Qin Shi Huangdi of the Qin dynasty (221–207 BC), unified China, although for only a short time, and set about the rational organization of writing. The "characters of imperial seals" (*zhuwen*) served as the basis for monumental writing, the *hsiao zhuwen*, as well as the simpler, more ductile and practical *lishu* ("clerical script," in which every character—*tseu*—is written within an imaginary grid). The names of famous calligraphers first appear in this period: Meng Tian (d. 210 BC), Li Si (d. 208 BC), and Cheng Miao (whose dates are uncertain).

The use of the old *lishu* (in Japanese, *reisho*) became generalized during the two Han dynasties (206 BC–AD 220). At the end

Below: Calligraphy engraved on stone, Warring States (453–221 BC) period. Neiraku Art Museum, Nara (Japan).

Bottom: Epitaph engraved on stone, period of the Northern Wei (Toba dynasty, AD 386–534). Forest of Stone Steles Museum, Xian (China).

15

of this period, known as the Eastern Han (AD 25–220), traditional characters were used to form three script styles that, variously modified, have continued to the present: the formal, standard script (*kaishu*; in Japanese, *kaisho*); the semicursive, or running, script (*xingshu*; in Japanese, *gyosho*); and the cursive (*caoshu*, erroneously called grass script; in Japanese, *sosho*). Thus the art of calligraphy also formally came into being, the greatest exponent of which was Zhang Zhi, famous for his *caoshu* style.

Finally, during the period of the Three Kingdoms (AD 220–280), China was divided among various rival kingdoms, giving rise to six local variations of the *kin-wen* style. These later came to be called 1) Confucian, or "Ancient," writing (*ku-wen*), the oldest, its characters engraved on stone steles and still today used in printing; 2) magical characters (*ki teseu*); 3) ancient seal characters (*zhuanshu*); 4) clerical script (*lishu* or also *li* of the Tsin); 5) imperial seal characters (*meu zhuanshu*); and 6) so-called bird seal script (*niaoshu*), used to decorate weapons and bronze vessels.

All these writing styles were engraved on stone steles, on wooden panels, or were included in bronze castings. An important development of Chinese writing took place around the first century AD with the invention of paper and ink (*mo*; in Japanese, *sumi*). Ink was first made from carbonized lacquer, sometimes with cinnabar; later it was made from lampblack and pine soot mixed with an adhesive gum and pressed to form solid cakes or sticks that were ground on an inkstone with water. To Chinese philosophers, both Confucian and Taoist, the gesture of mixing ink with water symbolized the two principles of being: life (the water) and death (the ink powder), or yin and yang, which unite to form the spiritual world of ideas.

Over the next three centuries, the invention of paper and ink proved determinant to the development of calligraphic art, which became increasingly important and appreciated, reaching full maturity during the Eastern Jin dynasty (AD 17–420), with the first two great masters, Wang Xizhi (AD 321–379; but other dates have been proposed, including AD 307–365 and AD 316–420) and his son Wang Xianzhi (AD 344–388), extremely refined artists, impeccable, fully proficient.

Seals for use on ceramics in various periods (*nianhao*) from the Qing dynasty (1644–911 BC). This calligraphy served as the basis for the creation of the decorative geometric writing of Islamic art.

In terms of chronology, I find that there are often discrepancies in dates between Japanese texts and Chinese texts, a problem I resolve by going with the date proposed by Chinese texts when dealing with Chinese calligraphy and with Japanese dates when dealing with Japanese calligraphy. Furthermore, two different methods are used for reckoning the dates of Chinese dynasties: the long chronology and the short chronology. The style of the two Wangs, courtly and impetuously sensitive, set the standard for aristocratic taste followed by the calligraphers and imperial officials in southern China, while in the north, under the reigns of the Toba tribes (who introduced Buddhist iconography from Afghanistan) in the two Wei dynasties (AD 534–550), the style was more severe and robust, less refined but virile.

The Tang dynasty (AD 618–907) saw the works of three great calligraphers who carried on the courtly tradition: Ouyang Xun (AD 557–641), Yu Shinan (AD 558–638), and Chu Suiliang (AD 596–641). Finally Yan Zhenqing (AD 709–785), the champion of the middle class forces hostile to the aristocracy, by then on the wane, united the northern and southern styles in a single hand that inspired the poets of the Song period (AD 960–1276), inspiring the pursuit of individual personality.

During the Yuan dynasty (1276–1368), China's emperors were Mongols, descendants of Genghis Khan. They eventually conquered the largest empire the world has known, bringing the various cultures of the Mediterranean into contact with China, resulting in

Above: Colophon from the Buddhist sutra, one of the oldest books printed on paper, datable to AD 947 and made with tabular woodcuts by Lei Yanmei.

Below: Grass writing (*caoshu*) from a rubbing made of an inscribed invocation (*t'ieh*) attributed to the Confucian sage Su Shi (also called Su Dongpo), Song dynasty (AD 960–1276).

one of history's greatest flowerings in the arts and literature.

The Ming dynasty (1368–1644), principally Chinese, was a long, profoundly nationalistic period with stylistic comings and goings, returns to tradition and movements in favor of a more accentuated originality. This period ended with the work of Dong Qichang (1556–1636), who reconciled the various trends and created a style that remained in use until the end of the nineteenth century, even through the decadence of the Qing dynasty (1644–1911). In a certain sense, despite its marked traditionalism, it is still in use today.

Ideograms are still in use in China. The many languages and dialects found throughout the country, although often "pronouncing" a grapheme in a different way, understand its meaning, which is the same to all of them. Writing thus serves as a kind of lingua franca understandable to all ethnic groups. This is also the case in Japan, where a character has the same meaning as in China even though it is pronounced in Japanese. The latest edition (1994) of the major Chinese dictionary called the *Zhonghua Zihai* contains 85,568 single characters, although many of them are obsolete or have fallen out of use. The major Japanese dictionary of *kanji* (Chinese characters), the *Dai Kan-Wa jiten*, compiled by Morohashi Tetsuji, contains 49,964 characters. It has been estimated that a Japanese person with an average education requires knowledge of four thousand Chinese characters, and in 1946 Japan's minister of public education identified the 1,850 Chinese characters indispensable for a good education. Students in elementary schools learn 80 of these characters their first year, 160 in the second, 200 in the third, 200 in the fourth, 185 in the fifth, and 181 in the sixth.

Origins and development of Japanese writing

Between the sixth and seventh century, the system of Chinese writing had come into widespread use in the regions bordering China, and following the route of the expansion of the Buddhist religion it had reached Korea and Japan. In their first year of elementary school, Japanese students are told the following story: in the year AD 391, a Japanese expedition arrived in Korea, at the time divided among several warring kingdoms, and gave considerable support to the king of Paikche in his struggle with the king of Koguryo.

Calligraphy by Kang Kuwei, Qing dynasty (1644–1911). National Museum, Tokyo.

18

Not many years later the king of Paikche repaid the king of Japan, sending him sumptuous clothing, jewels, and also a collection of books, thanks to which the Land of the Rising Sun came in contact with "written language." (We can point out in passing that Korea also later replaced Chinese characters with a syllabic system, called Hangul.) The first monks and scribes hired by the Japanese government came directly from China. The oldest Japanese inscription is one commemorating the construction of the Uji Bridge by the monk Doto of the Gango-ji Temple in Nara in AD 646.

During the eighth century, with the affirmation of Buddhism in Japan, the members of the Japanese court undertook the copying of the sacred texts of the new religion. They did so out of devotion, but also to show off their culture and refinement. In their efforts they were instructed by monks that remained faithful to the Tang tradition. The best-known calligraphy of this genre was created by the empress Komyo (AD 701–760), wife of Emperor Shomu.

In the ninth century the three calligraphers Ono no Michikaze (AD 894–966), Fujiwara no Sari (AD 944–998), and Fujiwara no Kozei (AD 962–1027)—known as the Sanseki ("Three Brush Traces")—broke with this tradition and in a certain sense moved away from the Chinese influence to create a Japanese style of calligraphy.

During the tenth century, since Chinese characters were poorly suited to the syntactic flow of the Japanese language, a phonetic syllabary was created using forty-eight signs, each derived from a Chinese character in its cursive form. This syllabary was known as the *hiragana*, a term that means "common loan characters," from *hira*, "common," and *kana*, "loan character." (In this word, *kana* is pronounced *gana* to make the pronunciation easier.) So it was that

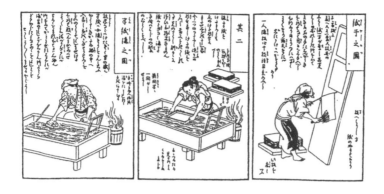

Various phases in the making of paper from the book *Kamisuki Chohoki*, first printed in Japan in 1798. Civica Raccolta Bertarelli, Milan.

the Japanese alphabet came into being. It would more accurately be called a "polysyllabic syllabary," but it has become customary to refer to it as an alphabet. Sometimes this ordering of kana is also called the *gojuon*, meaning the "fifty sounds" (following the reform of 1948 only forty-six signs are used, but sometimes two of the *y*'s and two of the *w*'s are included by custom).

In recent years scholars, most of all in the West, have sought to determine which Chinese ideographs were used for the establishment of the two Japanese alphabets, an endeavor that has not been without differences of opinion and debates. Each hypothesis remains only that, a hypothesis, for we possess no original documents. I have sought to indicate possible derivations, doing so on the basis of my knowledge of the Chinese characters, on the characters that are most current and recurrent in Japanese, and giving preference to the simplest and most probable.

Among the most ancient examples of hiragana writing is an eleventh-century copy of the *Kokinshu* (the *Kokin Wakashu*, a famous anthology of Japanese poetry), with the kana drawn in a fluid and harmoniously flowing way but accompanied by hiragana signs. Dating to not much later is an example of another poetry anthology, the *Wakan roei shu*, in which there are both Chinese characters and Japanese syllables.

The hiragana alphabet was later joined by the *katakana* (from *kata*, "part," and *kana*, "loan character," meaning in general "fragmentary kana"), simple writing signs designed for easy reading that have no origin in calligraphic art. This second alphabet seems to have been an outgrowth of the simplified and abridged system of notation used by

students of Buddhist religion when experiencing difficulty during their lessons in keeping up with all of the kana. Like the hiragana it is only phonetic, but it is more angular than the hiragana (katakana is known as "square kana," as opposed to the "smooth kana" of hiragana), and is poorly suited to calligraphic expression. In the end a sort of compromise was reached: the kanji were used for proper names, nouns, and the roots of verbs; the hiragana served to add and distinguish the sequence of Japanese grammar; and the katakana were used to explain foreign pronunciations or even (most of all today) to write out terms adopted from foreign languages (such as today's term *biru*, meaning, "building," and in fact derived from the English word). So it was that Japanese writing became in large part "synographic" (using different writing systems with the same meaning).

A bit of nomenclature will permit us to follow the evolution of the Japanese alphabets along the course of the centuries and ideas.

The fabrication of brushes in illustrations by Hosoi Kotaku (1658–1735) in *Kamjo Nifu*.

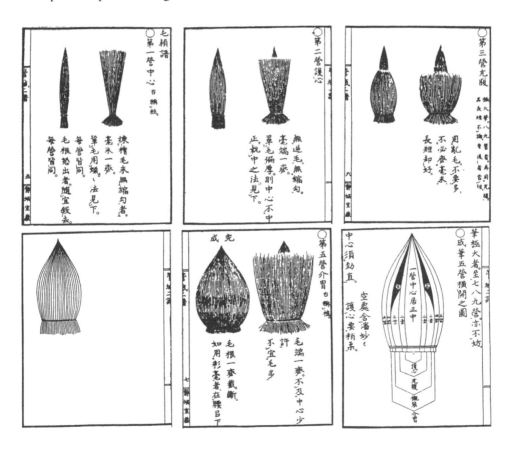

The original Chinese ideograms (*mana*) are called *kanji* (from *Han* or *Kan*, an ancient name of China, and *ji*, "character"), while the *kana* ("loan character") are Japanese phonetic characters (most of them expressed as two-letter syllables in English) derived from the kanji through processes of simplification, most of all through a process of selection that gave preference to the simplest kanji, which were used only as phonetic symbols and were not "read" with their ideographic meaning. Being an ideogram, a kanji does not represent a phonetic sound but rather an object or a concept to be seen but not "read" (thus the kanji for mountain leads us to say, "mountain" in English, "*montagne*" in French, "*san*" in Chinese, and "*yama*" in Japanese). In Japan, the kanji are usually given their native Japanese reading (a *kun* reading), but learned Japanese can read them with their Chinese-derived pronunciation (an *on* reading).

The first Japanese characters based on those Chinese were called *manyogana*, since they had been used to write an anthology of poetry, the *Manyoshu*. During the early Heian period (AD 794–866) the Japanese first made use of *onkana*, or kana with Chinese pronunciation (*on*); these represent the first phase in a development that, through later *sokana* (forms of characters intermediate between Chinese characters and the Japanese alphabet) led to the definitive formation of the hiragana. This alphabet, as said earlier, was joined by a second, called the katakana, derived from the *kaisho* and *gyosho* styles of script and used to give Japanese pronunciation to the Chinese ideographs in Buddhist texts. There was also a third, alternative series of kana letterforms, which constituted a kind of alphabet unto itself, the *hentaigana*. The kana spread and were soon adopted, but whether this adoption was imposed by a political power or by religion is not known. The adoption may have resulted from efforts carried out by the Fujiwara clan, which dominated the second Heian period (AD 866–1185) with the rise of the shogun (a sort of all-powerful prime minister, the first being Fujiwara Yoshifusa), controlling the feudal society of Japan; or it may have been accomplished by the Buddhist monk Kobo Daishi, called Kukai (AD 774–835), who during a mission to China learned not only ideographic writing but also the Devanagari phonetic alphabet, used to write Sanskrit; this gave him a thorough preparation for hiragana writing.

Motifs using *bonji* characters:
1. *Amakurikara*, the rain dragon, patron of the samurai, wound around a sword:
2. Invocation to *Fudo Myo-o*, Buddhist god of wisdom and fire;
3. The same invocation in the shape of a sword.

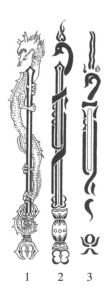

1 2 3

The invention of the alphabet gave access to writing to the women of Japan's court who, not being permitted to study Chinese, had not been able to write, although they were skilled poets. They put the alphabet to good use, giving a considerable impulse to the literature of the late Heian period (AD 794–1185) and perhaps also introducing a delicate and sensitive writing hand called *onnade,* "woman's hand," in contrast to the robust style called *otokode,* "man's hand." The masterpieces written by women during this period include *Genji-Monogatari* ("Tale of Genji") by Murasaki Shikibu; *Makura-no-soshi* ("The Pillow Book") by Sei Shonagon; and *Sanuki no Suke nikki* ("The Emperor Horikawa Diary"), by Sanuki no Suke. These were written entirely in hiragana.

There were two types of graphic layout, the isolated style (*hana-chigaki*), in which the characters, and in particular Chinese ideograms, were clearly separated from one another, and the continuous style (*ren-mentai*), in which the brush was hardly lifted from the page, with the kanji and kana written without separations between the signs even over an entire line of writing, spaces usually being provided only for the kana sign, the genitive *no.* The layouts acquired increasing vigor and aesthetic appeal, based on the techniques with which the brush was handled: initial stroke, stroke, final touch; but the result was also effected by whether one wrote with the brush held vertically or obliquely to the page, by rubbing the brush, dragging the brush, with the brush loaded with ink, with only a small amount of ink, and so on (*kihisu, sohitsu, shuhitsu; chocuhitsu, sokuhisu; sasuru, hiki; haboku, happitsu*).

Section of the *Genji Monogatari,* masterpiece by Murasaki Shikibu, a court figure during the height of the Heian dynasty (AD 794–1185).

The flair and the graphic-artistic versatility of Japanese culture used the graphemes of the two syllabaries in a wide variety of ways, from comic prints to the decoration on a *tsuba* (sword hilt), from ceramics to the *hata-jirushi* (vertical banners or streamers that warriors from the fifteenth century on wore attached to the backs of their armor, as identification). Nor was that by any means all, as indicated by an anecdotal aside, an historical episode that involved *bushido* (the code of the samurai), an episode that became extremely popular and was made into a large-scale theatrical drama: the *Chushingura*, or "Story of the Forty-seven Ronin." These "samurai without a master" vowed to avenge their master, who had been forced to commit *seppuku* (ritual suicide). As a step in their plot each of the forty-seven chose a letter of the hiragana as his conventional sign. The complete list still exists.

Most of all, Japanese calligraphy, in particular with the use of the more airy and symbolic kana, enjoyed a particular relationship to the sensibilities of the Zen schools, and the art of calligraphy came to express the principal emblematic values of mysticism as much as it did

Japanese calligraphy of the Chinese ideograms that indicate:
1. "ink"
2. "paper"
3. "beautiful writing"

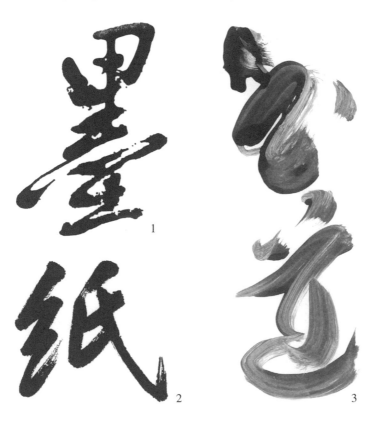

those of poetic visionaries. Over the centuries a series of Zen monks (in the three major sects of Japanese Zen, Rinzai, Soto, and Obaku, and their various schools) and male and female poets matched their graphic arts to the fascination of their verse. We have thus Daito Kokushi (1282–1337), founder of the Daitoku temple at Kyoto; Koetsu Honnami (1558–1637), a famous calligrapher but also an armsmaker and ceramist; the Zen master Hakuin Ekaku (1685–1768) of the Myoshin temple at Kyoto; the monk Ryokan (1757–1831); the Confucian Suo Nukina (1778–1863); and Tenrai (1872–1939), perhaps the most famous initiator of the modern school.

Listing all of Japan's schools of calligraphy, the various styles and temples in which the many great masters were active, would prove an arduous task and would use up many pages. A list of only the names and dates would cover many pages. Furthermore, the history of Japan's calligraphic art goes beyond the scope of a simple book on the alphabets of Japan, and the interested reader will have no difficulty finding many books dedicated to the subject. However, one cannot quietly pass over the fact that the beauty of Japanese calligraphy was of great importance to the art of the great Japanese painters of the eighteenth and nineteenth centuries, such as Utamaro (1753–1806), Hokusai (1760–1849), Hiroshige (1797–1858), and Toyokuni III (1786–1865), the artists who constituted the *ukiyo e* (pictures of the fleeting or floating world) school, which in turn had an enormous impact on the European artists of Impressionism, Post-Impressionism, and Modernism and which gave life to the powerful trend within nineteenth-century European art known as *Japonism*.

The influence of Japanese calligraphy on European arts

Today we hear a great deal about a presumed "clash of civilizations" in Europe, as though there had always been some kind of towering wall between the worlds of the East and the West that is only now being slowly disassembled. Nothing could be farther from the truth. The Eastern and European cultures have been close, connected, even interdependent over the course of the centuries, a fact that can easily be demonstrated. During the period of the Roman Empire (which had an embassy at Xian, China's capital, as well as in the Indian city of Pondicherry), the Silk Route was the principal artery for

the exchange of trade goods between China and Rome. The periodic invasions of Asiatic peoples, such as the Huns, Magyars, Mongols, Hunkars (credited with bringing to Europe the structural concept that led to Gothic architecture), and most of all the Ottomans, also constituted a means of artistic-cultural exchanges. Muslim inventions include hospitals, insane asylums, and universities, including the concept of the professorship. The University of Azhar in Cairo was founded in AD 970, shortly after the Qarawiyin at Fez in Morocco. Basing their statutes on those of the Islamic universities of Muslim Spain, the first European universities arose in Italy at Bologna in 1158 and Padua in 1221; in France at Toulouse in 1229 and Paris in 1257.

In the same way, by way of Islamic countries, in particular Turkey, paper arrived in Europe (invented in China in the first century AD), as indicated by its name, derived from the Turkish central-Asiatic root *kagh*, which in Uzbek became *kaghda*, in Turkish *kagit*, in Farsi, *kaghaz*, in Arabic, *kaghad*, and in Late Latin *charta*. From the Turkish *resmi* (a formal, official quantity) came the Arab term *rizmah*, and from this the Middle French *raime*, the Middle English *reme*, and finally the English *ream* (today a pack of five hundred pages, but originally a quantity of paper composed of twenty quires, so variously 480, 500, or 516 sheets). In 1276 Italy's first paper mill opened at Fabriano, with a Moorish director and three Moorish workers from Andalusia. A second paper mill opened in the same area in 1283, again under Moorish direction. Printing then arrived in Europe (invented in China around the third century AD) and the concept of movable type (elaborated in China before the third century). The compass was a Chinese invention; some believe the Italian word for compass, *bussola*, comes from *buxidam* ("box of boxwood"), but I believe it is derived from the Arabic *busala*. The *Shuo Wei* encyclopedia of the second century AD makes reference to this instrument. Chinese navigators transmitted knowledge of the compass to Moorish sailors who traded with India, and from them the compass was spread throughout the Mediterranean. It has been historically ascertained that the Flavio Gioia of Amalfi, formerly credited with inventing the compass, never in fact existed.

The painting and calligraphy of Japan, in particular the images of the *ukiyo-e* school, had an enormous influence on the development of art styles in Europe beginning in the nineteenth century.

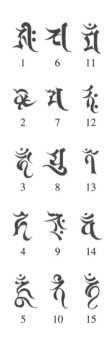

Bonji letters derived from the Devanagari (Indian alphabet of Sanskrit) modified in a Japanese style to decorate blades and *kosuka* (handles of folding daggers).
1. Amida;
2. Bishamonten;
3. Fudo Myo-o;
4. Jozo;
5. Kongo Yasha Myo-o;
6. Kwanon;
7. Marishiten;
8. Miroku;
9. Monju;
10. Yakushi;
11. Monju;
12. Shaka;
13. Shogun Jizo;
14. Dai Nichi;
15. Bato Kwanon.

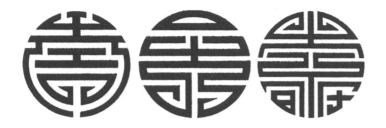

The styles succeeded one another from Impressionism to Post-Impressionism to Modernism (including Art Nouveau, known by different names in different countries: Liberty, Jugendstil, Floreale) and finally to abstract expressionism, action painting, and such avant-garde movements as Lettrism, all with greater or lesser connections to the art and calligraphy of Japan.

Chinese and Japanese art had already had impacts on the European art environment. During the eighteenth century it became stylish among Europe's high nobility to have a "Chinese room," which in wealthy homes and royal palaces imitated the themes and techniques of Chinese art, often including pieces imported from China. One of the most celebrated English cabinetmakers of the Neoclassical period, Thomas Chippendale (1718–1779), introduced new forms to his works by drawing on Gothic, Rococo, and also Chinese art. It was with the Universal Exposition held in Paris in 1867 that Japanese art began to make its greatest impact on European painting. Most of all it was the colored woodcuts of Utamaro, Hokusai, Hiroshige, and Toyokuni III that suggested new angles, new subjects, and new colors to the Impressionists. A good example is the portrait of Emile Zola by Edouard Manet (1832–1883), in which the French painter enriches the background with Japanese prints. References to Japanese prints became even more abundant with the leading painters of the Post-Impressionism and Symbolist styles, and in the paintings by Toulouse Lautrec (1864–1901), Gauguin (1848–1903), and Van Gogh (1853–1890) one can speak of Cloisonnism, which owes much to the orientalizing style.

By the middle of the nineteenth century new materials were coming into use in Europe in the field of architecture, most of all with structures in iron and glass. This movement put emphasis on artisan crafts, elevating them to the dignity of art and thus following the taste and aesthetic thinking of both China and Japan.

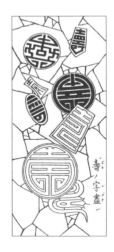

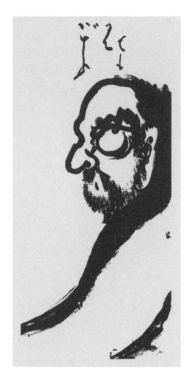 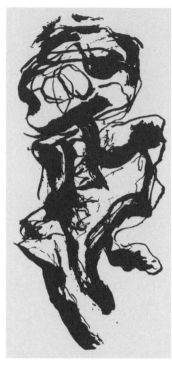

Far left: Hakuin
Ekaku (1685–1768),
The Sage Daruma.
Idemitsu Museum of
Arts, Tokyo.

Left: Karel Appel
(1921–2006),
*Figurative
Calligraphy*, 1953.
Private collection.

The applied arts became a form of sublime art, most of all serving
a decorative function based on the conciseness of simplified forms
and the use of ordinary, nonprecious materials. This period of
Modernism was called Arts and Crafts in Great Britain, Jugendstil
in Germany, Art Nouveau in France, and Floreale in Italy. In Italy
it was also known as Liberty, after Arthur Lasenby Liberty (1843–
1917), an English manufacturer who exported the products of the
Arts and Crafts movement. A natural outgrowth of Modernism was
Art Design, which to a certain extent based its early formation on
Japanese forms, and in fact today the leading exponents of the Art
Design movement in the West are the Japanese Isao Hosoe (with
works in the Victoria and Albert Museum in London as well as the
Metropolitan Museum of Art in New York) and Koryo Miura.

Japan has continued to inspire European arts, and when Euro-
pean artists took up stances in opposition to the classical greats of
figurative art, whether through recourse to rational art or Lettrism,
to the gestural arts or those of abstraction, they continued to draw
images and themes from Japan. The leading representatives of
these trends drew inspiration in a particular way from Japanese

calligraphy forms precisely because they embodied a distinct artistic essence whose meaning was unknown to anyone who did not know Japanese. Thus Henri Michaux (1899–1984) went to Japan in 1933, Mark Tobey (1890–1976) in 1934, and later Pierre Alechinsky (b. 1927), a member of the Cobra group, made a film in Japan on calligraphy. In 1952 Yves Klein (1928–1962) went to Japan and made a film on judo, and Julius Bissier (1893–1965) founded the Zen group in 1949. Knowledge of Zen Buddhism, which spread to Europe as a religious trend as well as a mystical way of thinking, completed the formation of the group of European artists who drew inspiration from Japanese arts. They were also joined by Japanese artists. From Zen art came the concepts of "emptiness" (*sunyata*); "angle painting" (which had so intrigued the Post-Impressionists); "spontaneous action" (*kotzu*), which helped form the American and European action painters; and the "essentiality of the simple" (*wabi*). European painters were most powerfully influenced by imitations of the Zen art of the Ashikaga period (1337–1537) or of the great master and Zen Buddhist priest Sesshu (1420–1506). In particular they adopted the Japanese technique of ink painting (*sumi-e*), using inks applied to soft paper with large brushes. This method proved the most suitable for the expression of improvisation.

Inevitably, Western enthusiasm for Zen painting, translated in rapid strokes that have no significance and only the appearance of Japanese writing, had a notable effect on various Japanese artists, most of all those living in the West. Particularly effected were Domoto, Imai, Onishi, Murakami, Sugai, and Suematsu, who were active in Paris; the sculptor Isamu Noguchi and the painters Okada, Ohashi, Yamaguchi, and Nishida were a active in the United States.

Without doubt an introduction as brief as this, with so few words, can present only a fleeting and superficial vision of an art as rich, diversified, profound, and sensitive as Japanese calligraphy. But no more than a few images will prove sufficient to a perceptive reader who is equally profound and sensitive. After all, there is the well-known proverb—itself believed to be of Sino-Japanese origin: "A picture is worth a thousand words."

SYNOPTIC TABLES

Although the traditional sequence of Japanese letters (see page 45) forms a beautiful poem, it is hardly practical. At the end of World War II, preference was generally given an arrangement of the letters that better facilitated looking them up and studying them. Since then, more and more graphemes have come into use to indicate sounds that are not basic to the Japanese language but that have been added as a result of the globalization of technical culture. These have been created by adding special signs to the usual basic letters.

The Japanese language has the same five vowels as English (*a, e, i, o, u*) as well as bisyllabic units (a consonant plus a vowel). The letter *n* is the only consonant that can be without a following vowel. There are nine consonants (*h, k, m, n, r, s, t, w, y*); combined with the five vowels they create the basic sounds, known as the **clear sounds** (*seion*). The first synoptic table given here (pages 32–33) matches the vowels at the top of the columns with the consonants, given in the horizontal rows, making it easy to quickly locate the grapheme that indicates each consonant-vowel unit.

Adding a kind of apostrophe (*nigori*) to the top right corner of one of twenty basic characters creates combinations with the consonants *g, z, d, b*. These graphemes (table pages 34–35) are called **voiced sounds** (*dakuon*).

Adding a small circle (*handakuten*) at the top right corner of one of five basic characters creates the combination of the vowel with the consonant *p*. These graphemes (see table pages 34–35) are called **half-voiced sounds** (*handakuon*).

The basic characters can also be followed by one of three small-sized letters (や, ゆ, よ in hiragana; ヤ, ユ, ヨ in katakana) to obtain another thirty-six sounds (table pages 36–39) that are called **contracted sounds** (*yoon*).

The Japanese language does not use punctuation marks; only in recent times has the period been introduced, used in particular to separate foreign names and terms written using Japanese characters. There is also a letter, depicted smaller, the つ (*tsu*) to reinforce

(double) the sound of a second consonant. For example: びく is read *biku* and びっく is read *bikku*. In *katakana,* the sign ─ elongates a vowel. For example: メル is read *meru* and メール is read *meeru*. It should always be borne in mind that

> The katakana is an alphabet in continuous evolution, both in terms of its given phonetic values and within its spheres of use. Not only do combinations exist that are not included in the hiragana, but over the years differences have been established to better distinguish, for example, the sound of the *v* from that of the *b* (from Mastrangelo, Ozawa, Saito, *Grammatica giapponese*, Milan 2006).

Pronunciation guidelines

Most of the characters in the two syllabaries are presented as two-letter syllables, easing pronunciation. There are then these general guidelines:

ch is always pronounced as in *cheese*

f is not aspirated, like the *wh* in *who*

g is always hard, like the *g* in *got*

h is aspirated as in German

j is pronounced like the *j* in *jelly*

s is always hard, like the *s* in *sat*

sh is pronounced like the *sh* in *sheep*

tsu is pronounced something like the *z* in *zoo*

u is more or less silent in the syllables *tsu* and *su*, most of all if located at the end of a word

w is pronounced like the *w* in *wagon*

y is pronounced like the letter *i*, even if it is considered a consonant

z is always pronounced hard, like the *z* in *zenith*

Neither the letter *l* nor the *v* exists in Japanese.

Phonetic shifts

In compound words, the clear sound at the beginning of the second word is replaced with the established voiced sound. As examples: *hashi-hari* becomes *hashi-bari*; *hiza-shime* becomes *hiza-jime*; such is the case with *kata-kana*, which becomes *kata-gana*.

31

a	i	u	e	o
あ	い	う	え	お
ka	ki	ku	ke	ko
か	き	く	け	こ
sa	si (shi)	su	se	so
さ	し	す	せ	そ
ta	ti (chi)	tu (tsu)	te	to
た	ち	つ	て	と
na	ni	nu	ne	no
な	に	ぬ	ね	の
ha	hi	hu (fu)	he	ho
は	ひ	ふ	へ	ほ
ma	mi	mu	me	mo
ま	み	む	め	も
ya	(î)	yu	(ê)	yo
や		ゆ		よ
ra	ri	ru	re	ro
ら	り	る	れ	ろ
(w)a	(w)i	(w)u	(w)e	(w)o
わ	ゐ		ゑ	を
n				
ん				

a	i	u	e	o
ア	イ	ウ	エ	オ
ka	ki	ku	ke	ko
カ	キ	ク	ケ	コ
sa	si (shi)	su	se	so
サ	シ	ス	セ	ソ
ta	ti (chi)	tu (tsu)	te	to
タ	チ	ツ	テ	ト
na	ni	nu	ne	no
ナ	ニ	ヌ	ネ	ノ
ha	hi	hu (fu)	he	ho
ハ	ヒ	フ	ヘ	ホ
ma	mi	mu	me	mo
マ	ミ	ム	メ	モ
ya	(î)	yu	(ê)	yo
ヤ		ユ		ヨ
ra	ri	ru	re	ro
ラ	リ	ル	レ	ロ
(w)a	(w)i	(w)u	(w)e	(w)o
ワ	ヰ		ヱ	ヲ
n				
ン				

VOICED SOUNDS* – HIRAGANA				
ga が	gi ぎ	gu ぐ	ge げ	go ご
za ざ	zi (ji) じ	zu ず	ze ぜ	zo ぞ
da だ	di (ji) ぢ	su (zu) づ	de で	do ど
ba ば	bi び	bu ぶ	be べ	bo ぼ

* Obtained with the addition of the *nigori* mark.

HALF-VOICED SOUNDS** – HIRAGANA				
pa ぱ	pi ぴ	pu ぷ	pe ぺ	po ぽ

** Obtained with the addition of the *handakuten* mark.

VOICED SOUNDS* – KATAKANA				
ga ガ	gi ギ	gu グ	ge ゲ	go ゴ
za ザ	zi (ji) ジ	zu ズ	ze ゼ	zo ゾ
da ダ	di (ji) ヂ	su (zu) ヅ	de デ	do ド
ba バ	bi ビ	bu ブ	be ベ	bo ボ

* Obtained with the addition of the *nigori* mark.

HALF-VOICED SOUNDS** – KATAKANA				
pa パ	pi ピ	pu プ	pe ペ	po ポ

** Obtained with the addition of the *handakuten* mark.

kya	kyu	kyo
きゃ	きゅ	きょ
gya	**gyu**	**gyo**
ぎゃ	ぎゅ	ぎょ
sha	**shu**	**sho**
しゃ	しゅ	しょ
ja	**ju**	**jo**
じゃ	じゅ	じょ
cha	**chu**	**cho**
ちゃ	ちゅ	ちょ
ja	**ju**	**jo**
ぢゃ	ぢゅ	ぢょ

kya	kyu	kyo
キャ	キュ	キョ
gya	**gyu**	**gyo**
ギャ	ギュ	ギョ
sha	**shu**	**sho**
シャ	シュ	ショ
ja	**ju**	**jo**
ジャ	ジュ	ジョ
cha	**chu**	**cho**
チャ	チュ	チョ
ja	**ju**	**ju**
ヂャ	ヂュ	ヂョ

37

nya	nyu	nyo
にゃ	にゅ	にょ
hya	hyu	hyo
ひゃ	ひゅ	ひょ
bya	byu	byo
びゃ	びゅ	びょ
pya	pyu	pyo
ぴゃ	ぴゅ	ぴょ
mya	myu	myo
みゃ	みゅ	みょ
rya	ryu	ryo
りゃ	りゅ	りょ

nya	nyu	nyo
ニャ	ニュ	ニョ
hya	hyu	hyo
ヒャ	ヒュ	ヒョ
bya	byu	byo
ビャ	ビュ	ビョ
pya	pyu	pyo
ピャ	ピュ	ピョ
mya	myu	myo
ミャ	ミュ	ミョ
rya	ryu	ryo
リャ	リュ	リョ

NUMBERS

Just as there are two systems of writing, the Chinese and the Japanese, there are two, relatively homologous, number systems. In both systems the written numbers are Chinese, but adding the hiragana letter *tsu* to the Chinese grapheme of the first nine numbers creates units that are read with Japanese pronunciation, as indicated in the table on the opposite page, which indicates pronunciation.

Like many Asian languages, Japanese makes use of counter words, or counters, a sort of suffix that varies according to the objects being counted; when a number does not refer to specific objects then the Japanese name for the number is used exclusively. There are many such counter words, including:

 For mechanical objects, such as radios, computers, cameras: *dai*.

 For narrow, long things like trees, cigarettes, and bottles: *hon*.

 For books, notebooks, and newspapers: *satsu*.

 For small animals like dogs, cats, hares, mice, and fish: *hiki* (*piki*).

 For birds: *wa*.

 For people: *ri* (*ichiwa*).

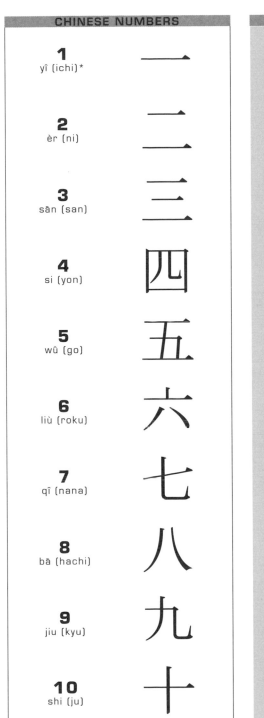

1 yī (ichi)*	**1** hitotsu
2 èr (ni)	**2** futatsu
3 sān (san)	**3** mittsu
4 si (yon)	**4** yottsu
5 wǔ (go)	**5** itsutsu
6 liù (roku)	**6** muttsu
7 qī (nana)	**7** nanatsu
8 bā (hachi)	**8** yattsu
9 jiǔ (kyu)	**9** kokonotsu
10 shi (ju)	**10** to

* Chinese pronunciation with Japanese in parenthesis.

RADICALS

The literal meaning of *kanji* is "Han character," in reference to
the Han dynasty, which as the Western Han and then the Eastern
Han ruled China from 206 BC to AD 220. In the Japanese view of
things, the Han dynasty was the period of the greatest splendor of
classical Chinese culture. Around the fifth century AD the Japa-
nese adopted Chinese writing, gradually adjusting it to their needs
over the course of the centuries, but the central nucleus always re-
mained unchanged and with it the synoptic values. Today in Japan
the kanji are commonly used to write the roots of verbs, adjectives,
and many ordinary vocabulary words.

In Japan as in China, the kanji are collated on the basis of the
recurring graphic components known as radicals. As a rule there
are 214 radicals, arranged in sequence according to the number of
their strokes, from those composed of a single stroke to the last,
which has seventeen. The table opposite presents the radicals
arranged by the number of their strokes.

The entries in dictionaries and vocabulary books are arranged
according to the radicals; thus a word cannot be looked up, as
in English, alphabetically, on the basis of spelling, and must
instead be located on the basis of its radical. The radical can
be to the left (usually), to the right, above, or under any given
ideogram; it can also be located inside it. The 214 radicals are
themselves ideograms with specific meanings. There are thus
radicals that are used on their own (for example: 口, *the mouth*)
along with compound radicals.

Other examples: the radical 口 (*the mouth*), located to the **left**
of 入 (*to enter/put inside*) forms the ideogram 叺 (*to put grain
or coal in a straw sack*); put to the **right** of 禾 (*not yet/sheep*)
it creates the ideogram 和 (*harmony*); put **above** 王 (*the king*)
it creates the ideogram 呈 (*to offer/indicate*); put **below** 天 (*the
sky*) it gives the ideogram 吞 (*to drink*). There are then radicals
in which the ideogram created is placed inside: in 囗 (*to sur-
round*) can be inserted the ideogram 古 (*old*), which creates 固
(*hard/solid*).

一 丨 丶 丿 **5** 乙 亅 二 亠 人 **10** 儿 入 八 冂 冖 **15** 冫 几 凵 刀 力 **20** 勹 匕 匚 匸 十

25 卜 卩 厂 厶 又 **30** 口 囗 土 士 夂 **35** 夊 夕 大 女 子 **40** 宀 寸 小 尢 尸 **45** 屮 山 巛 工

己 巾 干 幺 **50** 广 廴 廾 弋 弓 **55** 彐 彡 彳 心 戈 **60** 戶 手 支 攴 文 **65** 斗 斤 方 无 **70** 日

日 月 木 欠 **75** 止 歹 殳 毋 比 **80** 毛 氏 气 水 火 **85** 爪 父 爻 爿 片 **90** 牙 牛 犬 玄 **95** 玉

瓜 瓦 甘 生 用 **100** 田 疋 疒 癶 白 **105** 皮 皿 目 矛 矢 **110** 石 示 禸 禾 穴 **115** 立 竹 米 糸 **120**

缶 网 羊 羽 **145** 老 而 耒 耳 聿 肉 臣 自 至 **125** 臼 舌 舛 舟 艮 色 艸 虍 **130** 虫 血 行

衣 西 見 角 言 **145** 谷 豆 豕 豸 貝 **150** 赤 走 足 身 車 **155** 辛 辰 辵 邑 酉 **160** 釆 里 金 **165** 長

門 阜 隶 隹 雨 **170** 青 非 面 革 韋 **175** 韭 音 頁 風 飛 **180** 食 首 香 馬 骨 **185** 高 髟 **190** 鬥

鬯 鬲 鬼 魚 鳥 **195** 鹵 鹿 麥 麻 **200** 黃 黍 黑 黹 黽 **205** 鼎 鼓 鼠 鼻 齊 **210** 齒 龍 龜 **214** 龠

あ あ あ　　　　　　ふ　　　　　　　あ あ
あ あ　　　カ カ カ　　　　カ カ　あ あ あ
あ あ あ　カ カ　　ふ　　　　ろ　あ そ そ
そ そ そ　　　　　カ カ　　　る　そ そ
そ そ　ろ ろ　　　カ　　　　　　ふ ふ
ふ ふ ふ　　　　ナ ナ ナ　カ　　ふ ふ ふ ろ
ふ ふ ふ　本　ナ ヌ ナ　紙　　ろ ろ
ろ ろ ろ　　　ヌ ヌ　　　　　ろ ろ ろ
ろ ろ　　　　ヌ ナ　ナ
ろ ろ ろ　ヌ ナ　あ あ あ　ヌ
　　　　　ナ　あ あ あ　ナ あ
　　　　　　　あ　　ろ
ヂ ナ ナ ナ　　そ そ　　あ　　ナ ナ
ヂ ヂ ナ　ナ　そ そ そ　そ　ナ ナ ナ
ヂ ヂ ナ　あ　ふ ふ　ふ　ナ ナ ナ
ヂ ナ ナ ナ　そ　ふ ふ ふ　　カ カ
カ カ カ　ふ　土　ろ　ろ　カ カ
カ カ　　　　　　　　ふ　カ カ
カ カ カ　　　　　　ろ

THE ALPHABET

The letters in their traditional sequence

The sequence of the letters in our alphabet is based on that of the Greek alphabet, which begins *alpha*, *beta*, hence *alphabet*.

Reading the letters of the Japanese alphabet in their traditional order creates a poem, in fact, a Japanese *haiku*:

i-ro-ha-ni-ho-he-to	Flower colors and perfumes
chi-ri-nu-ru-wo	are soon scattered away
wa-ka yo-ta-re-so	For whom will the glory
tsu-ne-na-ra-mu	of this world remain eternal?
u-wi-no-o-ku-ya-ma	Today I came over the mountains
ke-fu-ko-e-te-a-sa	of this evanescent existence.
ki-yu-me-mi-shi-we-hi	All of this is but a dream
mo-se-su-n	That does not gladden me.

This is not the only alphabet that can be arranged in such a way; for example, there is an Indochinese alphabet in which the letters in sequence recite. *Anu ciuruku, data sawala, pada jaiana, maga batanga* ("There were two warriors, both devoted to their lord, both valorous, both died").

Note: As indicated earlier, the graphemes of the Japanese alphabets are based on simplifications of Chinese ideograms. No records exist to indicate precisely which ideograms were used. There are several hypotheses and not all of them agree. The versions presented in this book are based on two basic factors: the almost total adhesion to the basic graphemes of Chinese writing, the so-called radicals, and thus to the most common and simple ideograms, and the assonance between the sound of a Japanese grapheme and the pronunciation of a certain Chinese ideogram.

Opposite: Illustration from a poster by Ryuichi Yamashiro (b. 1920), *Tables, Paper, Terracotta,* 1958.

Writing characters (*kana* e *kanji*)

As with Chinese, in the Japanese language writing is done from top to bottom in lines arranged from right to left. A Japanese book typically begins on what would be the last page of a Western book. Today, however, the Western system is sometimes used in Japan, with texts composed in horizontal lines to be read from left to right. Both in Chinese and Japanese, each character is

Kana
In the tables that follow, each double-page spread is dedicated to one character of the Japanese alphabet (*kana*); the letters are arranged in their traditional sequence.

The two alphabets
The left page gives the letter in its hiragana version; the right in its katakana version.

The strokes
A vertical column indicates the correct sequence for writing the strokes that compose each character.

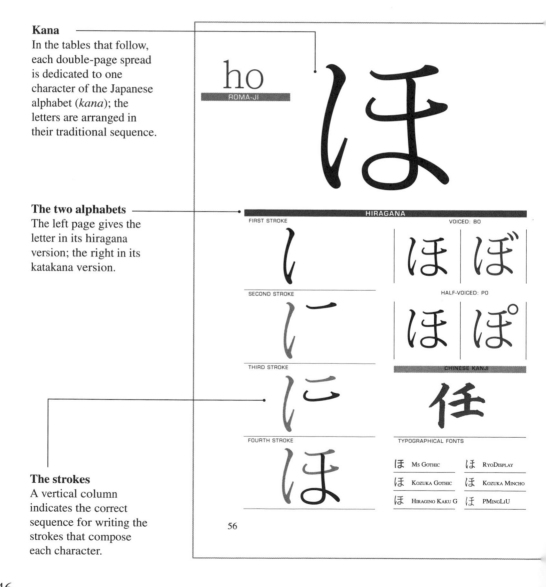

ho
ROMA-JI

HIRAGANA

FIRST STROKE

SECOND STROKE

THIRD STROKE

FOURTH STROKE

VOICED: BO

ほ ぼ

HALF-VOICED: PO

ほ ぽ

CHINESE KANJI

任

TYPOGRAPHICAL FONTS

ほ	Ms Gothic	ほ	Ryo Display
ほ	Kozuka Gothic	ほ	Kozuka Mincho
ほ	Hiragino Kaku G	ほ	PMingLiU

56

composed of a series of strokes executed in a prescribed order. Strokes are made from the top down and from the left to the right; horizontal lines are drawn before verticals, whether they are alongside them or cross them. The central stroke is completed before symmetrical parts, and the strokes are made from the inside outward. The final base line is added when the central stroke has been completed; vertical or horizontal lines that cross the entire ideogram are written last.

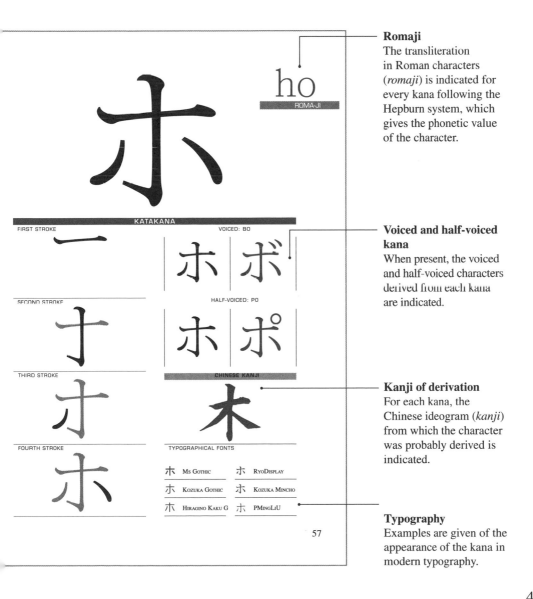

Romaji
The transliteration in Roman characters (*romaji*) is indicated for every kana following the Hepburn system, which gives the phonetic value of the character.

Voiced and half-voiced kana
When present, the voiced and half-voiced characters derived from each kana are indicated.

Kanji of derivation
For each kana, the Chinese ideogram (*kanji*) from which the character was probably derived is indicated.

Typography
Examples are given of the appearance of the kana in modern typography.

57

47

i

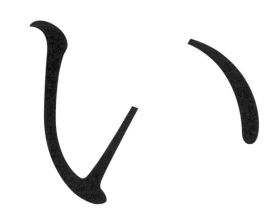

HIRAGANA

FIRST STROKE

VOICED

SECOND STROKE

HALF-VOICED

THIRD STROKE

CHINESE KANJI

FOURTH STROKE

TYPOGRAPHICAL FONTS

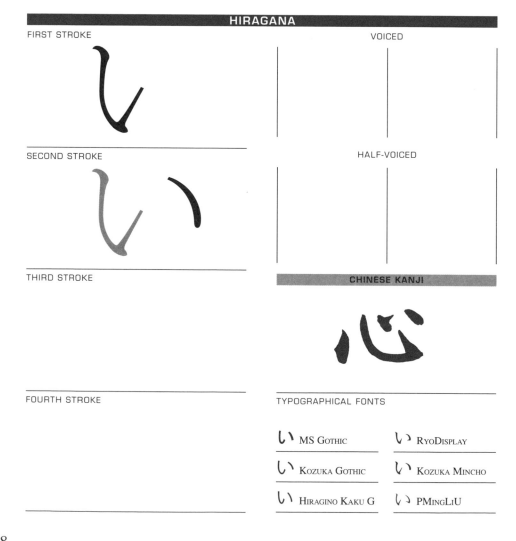

い MS Gothic

い RyoDisplay

い Kozuka Gothic

い Kozuka Mincho

い Hiragino Kaku G

い PMingLiU

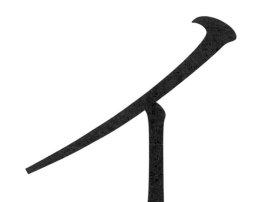

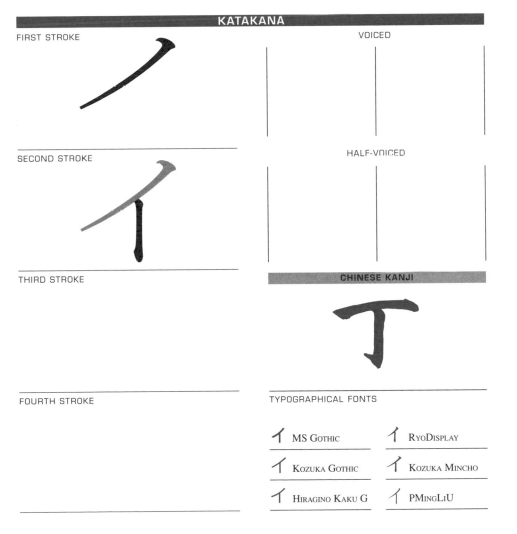

KATAKANA

FIRST STROKE

VOICED

SECOND STROKE

HALF-VOICED

THIRD STROKE

CHINESE KANJI

FOURTH STROKE

TYPOGRAPHICAL FONTS

イ MS Gothic

イ RyoDisplay

イ Kozuka Gothic

イ Kozuka Mincho

イ Hiragino Kaku G

イ PMingLiU

ro

ROMAJI

HIRAGANA

FIRST STROKE

VOICED

SECOND STROKE

HALF-VOICED

THIRD STROKE

CHINESE KANJI

石

FOURTH STROKE

TYPOGRAPHICAL FONTS

ろ	MS GOTHIC	ろ	RYODISPLAY
ろ	KOZUKA GOTHIC	ろ	KOZUKA MINCHO
ろ	HIRAGINO KAKU G	ろ	PMINGLIU

KATAKANA

FIRST STROKE

VOICED

SECOND STROKE

HALF-VOICED

THIRD STROKE

CHINESE KANJI

FOURTH STROKE

TYPOGRAPHICAL FONTS

☐ MS GOTHIC ☐ RYODISPLAY

☐ KOZUKA GOTHIC ☐ KOZUKA MINCHO

☐ HIRAGINO KAKU G ☐ PMINGLIU

ha

ROMAJI

HIRAGANA

FIRST STROKE

VOICED: BA

SECOND STROKE

HALF-VOICED: PA

THIRD STROKE

CHINESE KANJI

FOURTH STROKE

TYPOGRAPHICAL FONTS

は MS Gothic は RyoDisplay

は Kozuka Gothic は Kozuka Mincho

は Hiragino Kaku G は PMingLiU

52

KATAKANA

FIRST STROKE

VOICED: BA

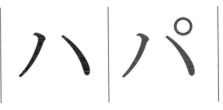

SECOND STROKE

HALF-VOICED: PA

THIRD STROKE

CHINESE KANJI

FOURTH STROKE

TYPOGRAPHICAL FONTS

ハ MS GOTHIC	ハ RYODISPLAY
ハ KOZUKA GOTHIC	ハ KOZUKA MINCHO
ハ HIRAGINO KAKU G	ハ PMINGLIU

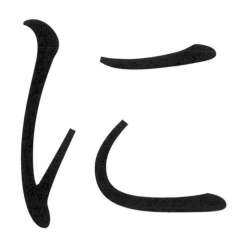

HIRAGANA

FIRST STROKE

VOICED

SECOND STROKE

HALF-VOICED

THIRD STROKE

CHINESE KANJI

仇

FOURTH STROKE

TYPOGRAPHICAL FONTS

に MS Gothic に RyoDisplay

に Kozuka Gothic に Kozuka Mincho

に Hiragino Kaku G に PMingLiU

FIRST STROKE

VOICED

SECOND STROKE

HALF-VOICED

THIRD STROKE

CHINESE KANJI

FOURTH STROKE

TYPOGRAPHICAL FONTS

ニ MS GOTHIC	ニ RYODISPLAY
ニ KOZUKA GOTHIC	ニ KOZUKA MINCHO
ニ HIRAGINO KAKU G	ニ PMINGLIU

ho

ROMAJI

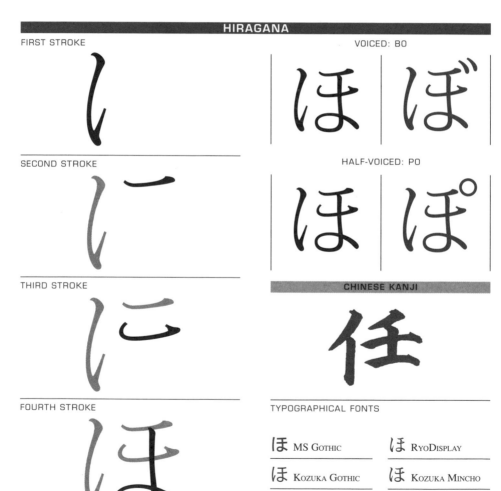

HIRAGANA

FIRST STROKE

SECOND STROKE

THIRD STROKE

FOURTH STROKE

VOICED: BO

HALF-VOICED: PO

CHINESE KANJI

TYPOGRAPHICAL FONTS

ほ MS GOTHIC

ほ KOZUKA GOTHIC

ほ HIRAGINO KAKU G

ほ RYODISPLAY

ほ KOZUKA MINCHO

ほ PMINGLIU

56

KATAKANA

FIRST STROKE

VOICED: BO

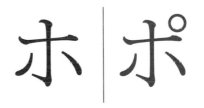

SECOND STROKE

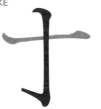

HALF-VOICED: PO

THIRD STROKE

CHINESE KANJI

FOURTH STROKE

TYPOGRAPHICAL FONTS

ホ MS GOTHIC ホ RYODISPLAY

ホ KOZUKA GOTHIC ホ KOZUKA MINCHO

ホ HIRAGINO KAKU G ホ PMINGLIU

he

HIRAGANA

FIRST STROKE

VOICED: BE

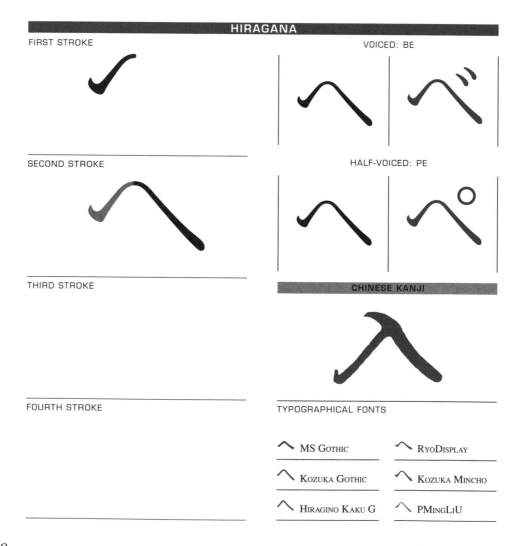

SECOND STROKE

HALF-VOICED: PE

THIRD STROKE

CHINESE KANJI

FOURTH STROKE

TYPOGRAPHICAL FONTS

∧	MS GOTHIC	∧	RYODISPLAY
∧	KOZUKA GOTHIC	∧	KOZUKA MINCHO
∧	HIRAGINO KAKU G	∧	PMINGLIU

KATAKANA

FIRST STROKE

VOICED: BE

SECOND STROKE

HALF-VOICED: PE

THIRD STROKE

CHINESE KANJI

FOURTH STROKE

TYPOGRAPHICAL FONTS

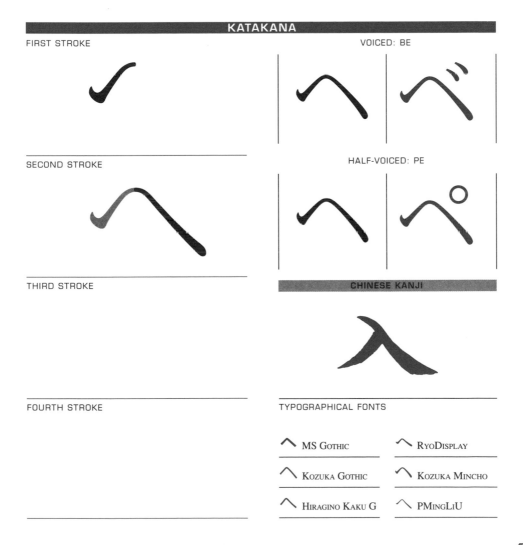

∧ MS Gothic		∧ RyoDisplay
∧ Kozuka Gothic		∧ Kozuka Mincho
∧ Hiragino Kaku G		∧ PMingLiU

to

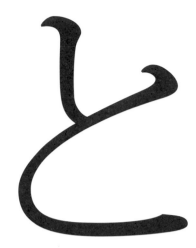

HIRAGANA

FIRST STROKE

VOICED: DO

と ど

SECOND STROKE

HALF-VOICED

THIRD STROKE

CHINESE KANJI

巴

FOURTH STROKE

TYPOGRAPHICAL FONTS

と MS Gothic と RyoDisplay

と Kozuka Gothic と Kozuka Mincho

と Hiragino Kaku G と PMingLiU

KATAKANA

FIRST STROKE

VOICED: DO

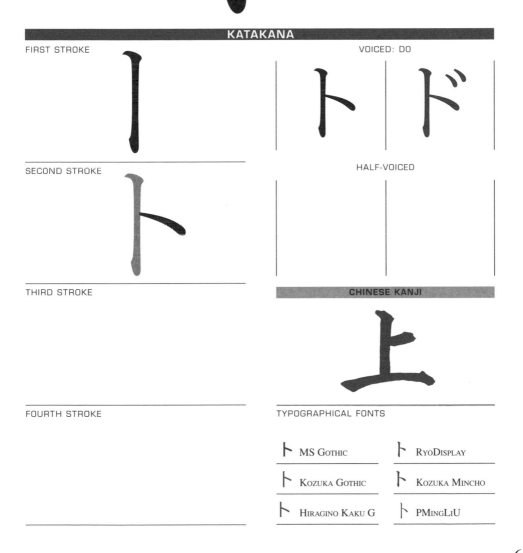

SECOND STROKE

HALF-VOICED

THIRD STROKE

CHINESE KANJI

FOURTH STROKE

TYPOGRAPHICAL FONTS

ト MS Gothic ト RyoDisplay

ト Kozuka Gothic ト Kozuka Mincho

ト Hiragino Kaku G ㅏ PMingLiU

chi

HIRAGANA

FIRST STROKE

VOICED: JI

ち ぢ

SECOND STROKE

HALF-VOICED

THIRD STROKE

CHINESE KANJI

古

FOURTH STROKE

TYPOGRAPHICAL FONTS

ち MS Gothic	ち RyoDisplay
ち Kozuka Gothic	ち Kozuka Mincho
ち Hiragino Kaku G	ち PMingLiU

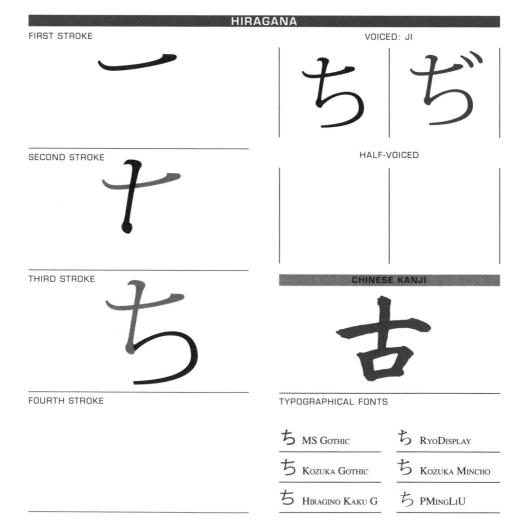

KATAKANA

FIRST STROKE

VOICED: JI

チ ヂ

SECOND STROKE

HALF-VOICED

THIRD STROKE

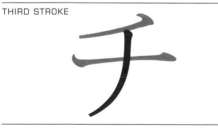

CHINESE KANJI

子

FOURTH STROKE

TYPOGRAPHICAL FONTS

チ MS Gothic チ RyoDisplay

チ Kozuka Gothic チ Kozuka Mincho

チ Hiragino Kaku G チ PMingLiU

ri

HIRAGANA

FIRST STROKE	VOICED

SECOND STROKE	HALF-VOICED

THIRD STROKE	CHINESE KANJI

旧

FOURTH STROKE

TYPOGRAPHICAL FONTS

り MS GOTHIC

り RYODISPLAY

り KOZUKA GOTHIC

り KOZUKA MINCHO

り HIRAGINO KAKU G

り PMINGLIU

KATAKANA

FIRST STROKE

VOICED

SECOND STROKE

HALF-VOICED

THIRD STROKE

CHINESE KANJI

刑

FOURTH STROKE

TYPOGRAPHICAL FONTS

リ MS GOTHIC

リ RYODISPLAY

リ KOZUKA GOTHIC

リ KOZUKA MINCHO

リ HIRAGINO KAKU G

リ PMINGLIU

65

HIRAGANA

FIRST STROKE

VOICED

SECOND STROKE

HALF-VOICED

THIRD STROKE

CHINESE KANJI

奴

FOURTH STROKE

TYPOGRAPHICAL FONTS

ぬ MS Gothic

ぬ RyoDisplay

ぬ Kozuka Gothic

ぬ Kozuka Mincho

ぬ Hiragino Kaku G

ぬ PMingLiU

KATAKANA

FIRST STROKE

VOICED

SECOND STROKE

HALF-VOICED

THIRD STROKE

CHINESE KANJI

FOURTH STROKE

TYPOGRAPHICAL FONTS

ヌ MS Gothic ヌ RyoDisplay

ヌ Kozuka Gothic ヌ Kozuka Mincho

ヌ Hiragino Kaku G ヌ PMingLiU

ru

HIRAGANA

FIRST STROKE

VOICED

SECOND STROKE

HALF-VOICED

THIRD STROKE

CHINESE KANJI

召

FOURTH STROKE

TYPOGRAPHICAL FONTS

る	MS Gothic	る	RyoDisplay
る	Kozuka Gothic	る	Kozuka Mincho
る	Hiragino Kaku G	る	PMingLiU

KATAKANA

FIRST STROKE

SECOND STROKE

THIRD STROKE

FOURTH STROKE

VOICED

HALF-VOICED

CHINESE KANJI

丸

TYPOGRAPHICAL FONTS

ル MS Gothic		ル RyoDisplay
ル Kozuka Gothic		ル Kozuka Mincho
ル Hiragino Kaku G		ル PMingLiU

HIRAGANA

FIRST STROKE

VOICED

SECOND STROKE

HALF-VOICED

THIRD STROKE

CHINESE KANJI

右

FOURTH STROKE

TYPOGRAPHICAL FONTS

を MS Gothic を RyoDisplay

を Kozuka Gothic を Kozuka Mincho

を Hiragino Kaku G を PMingLiU

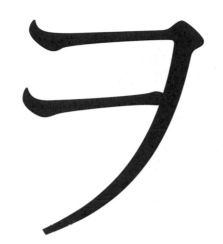

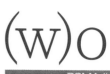

KATAKANA

FIRST STROKE

VOICED

SECOND STROKE

HALF-VOICED

THIRD STROKE

CHINESE KANJI

FOURTH STROKE

TYPOGRAPHICAL FONTS

ヲ MS GOTHIC ヲ RYODISPLAY

ヲ KOZUKA GOTHIC ヲ KOZUKA MINCHO

ヲ HIRAGINO KAKU G ヲ PMINGLIU

(w)a

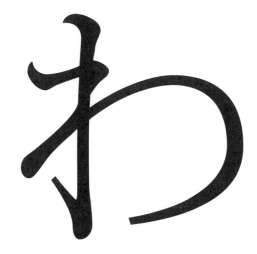

HIRAGANA

FIRST STROKE

VOICED

SECOND STROKE

HALF-VOICED

THIRD STROKE

CHINESE KANJI

朽

FOURTH STROKE

TYPOGRAPHICAL FONTS

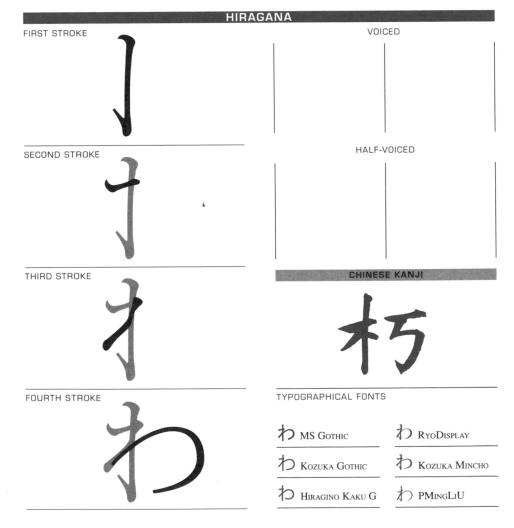

わ MS Gothic

わ RyoDisplay

わ Kozuka Gothic

わ Kozuka Mincho

わ Hiragino Kaku G

わ PMingLiU

KATAKANA

FIRST STROKE

SECOND STROKE

THIRD STROKE

FOURTH STROKE

VOICED

HALF-VOICED

CHINESE KANJI

匂

TYPOGRAPHICAL FONTS

ワ MS Gothic	ワ RyoDisplay
ワ Kozuka Gothic	ワ Kozuka Mincho
ワ Hiragino Kaku G	ワ PMingLiU

ka
ROMAJI

HIRAGANA		

FIRST STROKE

ー

VOICED: GA

か が

SECOND STROKE

つ

HALF-VOICED

THIRD STROKE

カ

CHINESE KANJI

加

FOURTH STROKE

か

TYPOGRAPHICAL FONTS

か MS Gothic	か RyoDisplay
か Kozuka Gothic	か Kozuka Mincho
か Hiragino Kaku G	か PMingLiU

KATAKANA

FIRST STROKE

VOICED: GA

SECOND STROKE

HALF-VOICED

THIRD STROKE

CHINESE KANJI

FOURTH STROKE

TYPOGRAPHICAL FONTS

力 MS GOTHIC

力 RYODISPLAY

力 KOZUKA GOTHIC

力 KOZUKA MINCHO

力 HIRAGINO KAKU G

力 PMINGLIU

HIRAGANA

FIRST STROKE

VOICED

SECOND STROKE

HALF-VOICED

THIRD STROKE

CHINESE KANJI

FOURTH STROKE

TYPOGRAPHICAL FONTS

よ MS GOTHIC よ RYODISPLAY

よ KOZUKA GOTHIC よ KOZUKA MINCHO

よ HIRAGINO KAKU G よ PMINGLIU

KATAKANA

FIRST STROKE

VOICED

SECOND STROKE

HALF-VOICED

THIRD STROKE

CHINESE KANJI

当

FOURTH STROKE

TYPOGRAPHICAL FONTS

ヨ MS GOTHIC ヨ RYODISPLAY

ヨ KOZUKA GOTHIC ヨ KOZUKA MINCHO

ヨ HIRAGINO KAKU G ヨ PMINGLIU

ta

ROMAJI

HIRAGANA

FIRST STROKE

VOICED: DA

た　だ

SECOND STROKE

HALF-VOICED

THIRD STROKE

CHINESE KANJI

左

FOURTH STROKE

TYPOGRAPHICAL FONTS

た MS GOTHIC　た RYODISPLAY

た KOZUKA GOTHIC　た KOZUKA MINCHO

た HIRAGINO KAKU G　た PMINGLIU

タ

KATAKANA

FIRST STROKE

VOICED: DA

タ ダ

SECOND STROKE

HALF-VOICED

THIRD STROKE

CHINESE KANJI

FOURTH STROKE

TYPOGRAPHICAL FONTS

タ MS GOTHIC

タ RYODISPLAY

タ KOZUKA GOTHIC

タ KOZUKA MINCHO

タ HIRAGINO KAKU G

夕 PMINGLIU

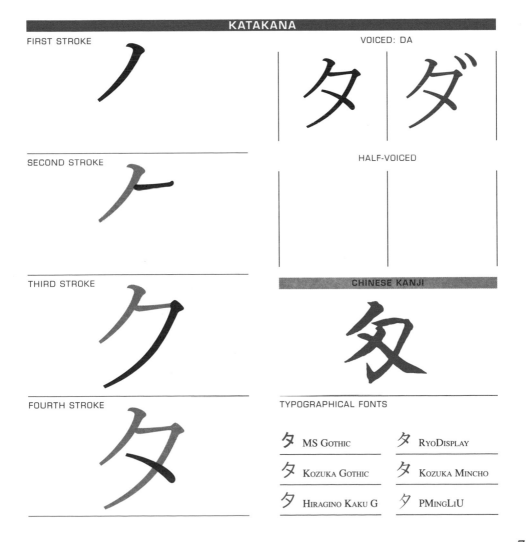

79

HIRAGANA

FIRST STROKE

VOICED

SECOND STROKE

HALF-VOICED

THIRD STROKE

CHINESE KANJI

FOURTH STROKE

TYPOGRAPHICAL FONTS

れ MS GOTHIC

れ RYODISPLAY

れ KOZUKA GOTHIC

れ KOZUKA MINCHO

れ HIRAGINO KAKU G

れ PMINGLIU

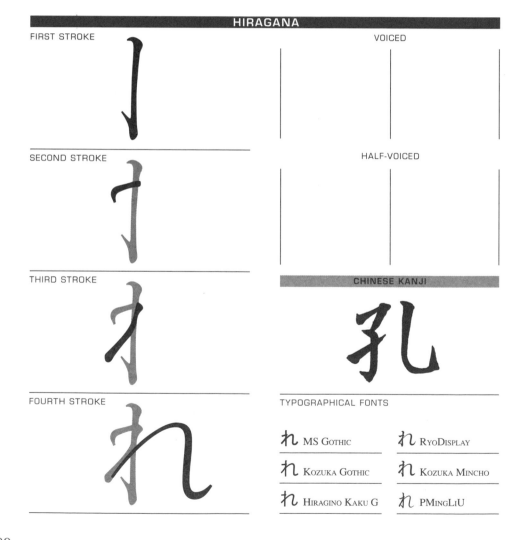

KATAKANA

FIRST STROKE

VOICED

SECOND STROKE

HALF-VOICED

THIRD STROKE

CHINESE KANJI

FOURTH STROKE

TYPOGRAPHICAL FONTS

レ MS Gothic	レ RyoDisplay
レ Kozuka Gothic	レ Kozuka Mincho
レ Hiragino Kaku G	レ PMingLiU

SO

HIRAGANA

FIRST STROKE

VOICED: ZO

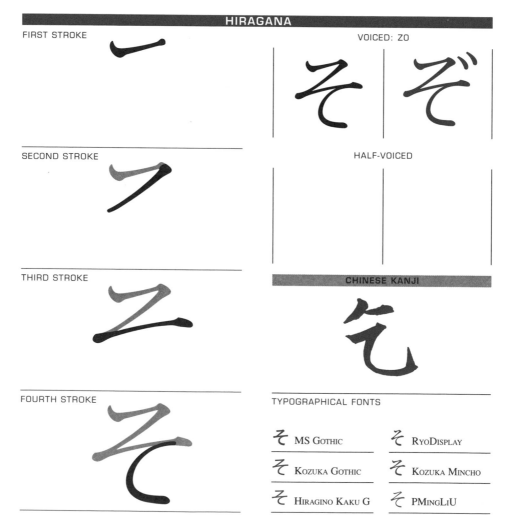

SECOND STROKE

HALF-VOICED

THIRD STROKE

CHINESE KANJI

FOURTH STROKE

TYPOGRAPHICAL FONTS

そ MS GOTHIC	そ RYODISPLAY
そ KOZUKA GOTHIC	そ KOZUKA MINCHO
そ HIRAGINO KAKU G	そ PMINGLIU

KATAKANA

FIRST STROKE

VOICED: ZO

SECONDO SEGNO

HALF-VOICED

THIRD STROKE

CHINESE KANJI

FOURTH STROKE

TYPOGRAPHICAL FONTS

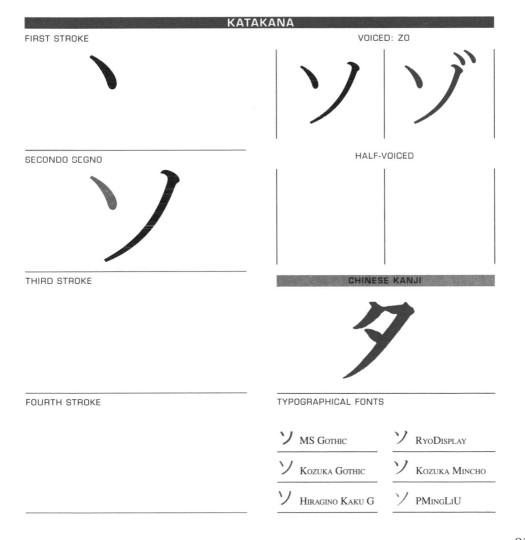

ソ MS Gothic ソ RyoDisplay

ソ Kozuka Gothic ソ Kozuka Mincho

ソ Hiragino Kaku G ソ PMingLiU

tsu
ROMAJI

HIRAGANA

FIRST STROKE

VOICED: ZU

SECOND STROKE

HALF-VOICED

THIRD STROKE

CHINESE KANJI

刀

FOURTH STROKE

TYPOGRAPHICAL FONTS

つ MS GOTHIC

つ RYODISPLAY

つ KOZUKA GOTHIC

つ KOZUKA MINCHO

つ HIRAGINO KAKU G

つ PMINGLIU

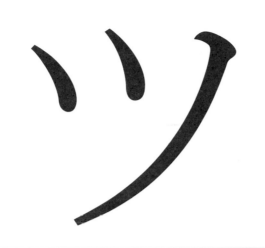

KATAKANA

FIRST STROKE

VOICED: ZU

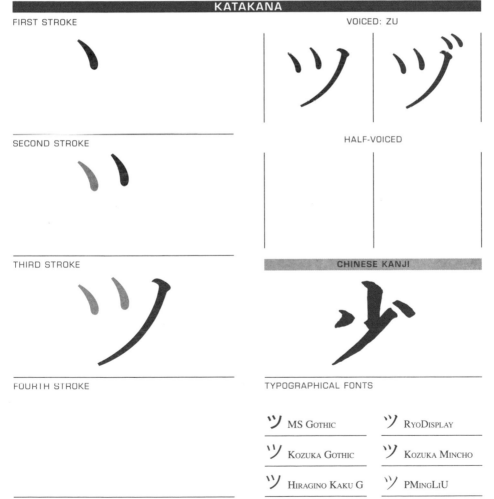

SECOND STROKE

HALF-VOICED

THIRD STROKE

CHINESE KANJI

FOURTH STROKE

TYPOGRAPHICAL FONTS

ツ MS Gothic	ツ RyoDisplay
ツ Kozuka Gothic	ツ Kozuka Mincho
ツ Hiragino Kaku G	ツ PMingLiU

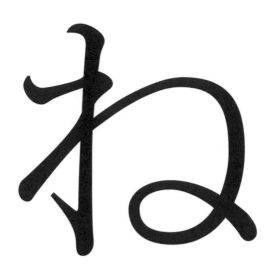

HIRAGANA

FIRST STROKE

SECOND STROKE

THIRD STROKE

FOURTH STROKE

VOICED

HALF-VOICED

CHINESE KANJI

切

TYPOGRAPHICAL FONTS

ね MS GOTHIC ね RYODISPLAY

ね KOZUKA GOTHIC ね KOZUKA MINCHO

ね HIRAGINO KAKU G ね PMINGLIU

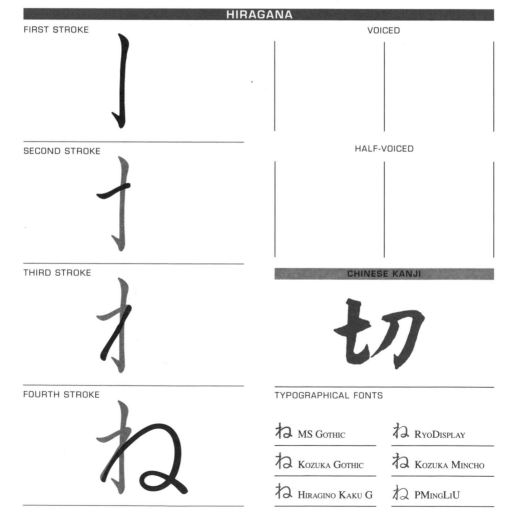

KATAKANA

FIRST STROKE

SECOND STROKE

THIRD STROKE

FOURTH STROKE

VOICED

HALF-VOICED

CHINESE KANJI

永

TYPOGRAPHICAL FONTS

ネ MS GOTHIC	ネ RYODISPLAY
ネ KOZUKA GOTHIC	ネ KOZUKA MINCHO
ネ HIRAGINO KAKU G	ネ PMINGLIU

na

HIRAGANA

FIRST STROKE

VOICED

SECOND STROKE

HALF-VOICED

THIRD STROKE

CHINESE KANJI

扱

FOURTH STROKE

TYPOGRAPHICAL FONTS

な MS GOTHIC	な RYODISPLAY
な KOZUKA GOTHIC	な KOZUKA MINCHO
な HIRAGINO KAKU G	な PMINGLIU

KATAKANA

FIRST STROKE

VOICED

SECOND STROKE

HALF-VOICED

THIRD STROKE

CHINESE KANJI

FOURTH STROKE

TYPOGRAPHICAL FONTS

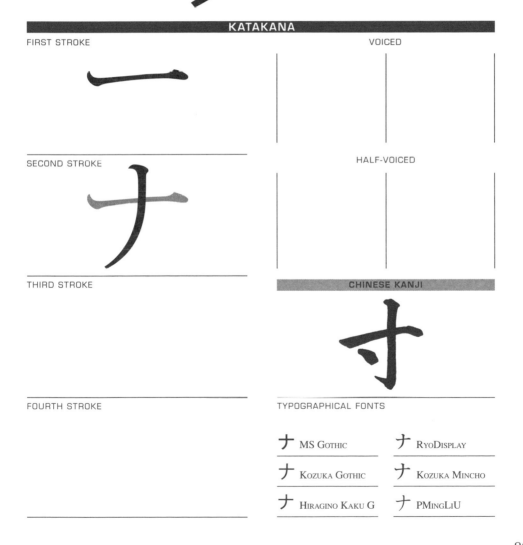

ナ MS GOTHIC	ナ RYODISPLAY
ナ KOZUKA GOTHIC	ナ KOZUKA MINCHO
ナ HIRAGINO KAKU G	ナ PMINGLIU

ra

HIRAGANA

FIRST STROKE

VOICED

SECOND STROKE

HALF-VOICED

THIRD STROKE

CHINESE KANJI

FOURTH STROKE

TYPOGRAPHICAL FONTS

ら MS Gothic ら RyoDisplay

ら Kozuka Gothic ら Kozuka Mincho

ら Hiragino Kaku G ら PMingLiU

KATAKANA

FIRST STROKE

VOICED

SECOND STROKE

HALF-VOICED

THIRD STROKE

CHINESE KANJI

万

FOURTH STROKE

TYPOGRAPHICAL FONTS

ラ MS Gothic ラ RyoDisplay

ラ Kozuka Gothic ラ Kozuka Mincho

ラ Hiragino Kaku G ラ PMingLiU

mu

HIRAGANA

FIRST STROKE

VOICED

SECOND STROKE

HALF-VOICED

THIRD STROKE

CHINESE KANJI

劫

FOURTH STROKE

TYPOGRAPHICAL FONTS

む MS Gothic

む RyoDisplay

む Kozuka Gothic

む Kozuka Mincho

む Hiragino Kaku G

む PMingLiU

KATAKANA

FIRST STROKE

VOICED

SECOND STROKE

HALF-VOICED

THIRD STROKE

CHINESE KANJI

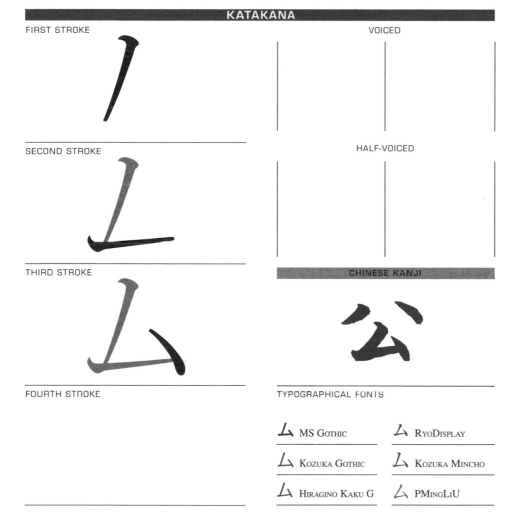

FOURTH STROKE

TYPOGRAPHICAL FONTS

ム MS GOTHIC

ム RYODISPLAY

ム KOZUKA GOTHIC

ム KOZUKA MINCHO

ム HIRAGINO KAKU G

ム PMINGLIU

u

HIRAGANA

FIRST STROKE

VOICED

SECOND STROKE

HALF-VOICED

THIRD STROKE

CHINESE KANJI

占

FOURTH STROKE

TYPOGRAPHICAL FONTS

う	MS GOTHIC	う	RYODISPLAY
う	KOZUKA GOTHIC	う	KOZUKA MINCHO
う	HIRAGINO KAKU G	う	PMINGLIU

KATAKANA

FIRST STROKE

SECOND STROKE

THIRD STROKE

FOURTH STROKE

VOICED

HALF-VOICED

CHINESE KANJI

向

TYPOGRAPHICAL FONTS

ウ MS GOTHIC

ウ KOZUKA GOTHIC

ウ HIRAGINO KAKU G

ウ RYODISPLAY

ウ KOZUKA MINCHO

ウ PMINGLIU

HIRAGANA

FIRST STROKE	VOICED

SECOND STROKE	HALF-VOICED

THIRD STROKE	CHINESE KANJI

肋

FOURTH STROKE	TYPOGRAPHICAL FONTS

ゐ MS Gothic ゐ RyoDisplay

ゐ Kozuka Gothic ゐ Kozuka Mincho

ゐ Hiragino Kaku G ゐ PMingLiU

KATAKANA

FIRST STROKE

VOICED

SECOND STROKE

HALF-VOICED

THIRD STROKE

CHINESE KANJI

牛

FOURTH STROKE

TYPOGRAPHICAL FONTS

卉 MS GOTHIC 卉 RYODISPLAY

卉 KOZUKA GOTHIC 卉 KOZUKA MINCHO

卉 HIRAGINO KAKU G 卉 PMINGLIU

HIRAGANA

FIRST STROKE

VOICED

SECOND STROKE

HALF-VOICED

THIRD STROKE

CHINESE KANJI

内

FOURTH STROKE

TYPOGRAPHICAL FONTS

の MS GOTHIC の RYODISPLAY

の KOZUKA GOTHIC の KOZUKA MINCHO

の HIRAGINO KAKU G の PMINGLIU

KATAKANA

FIRST STROKE

SECOND STROKE

THIRD STROKE

FOURTH STROKE

VOICED

HALF-VOICED

CHINESE KANJI

TYPOGRAPHICAL FONTS

/ MS GOTHIC	/ RYODISPLAY
/ KOZUKA GOTHIC	/ KOZUKA MINCHO
/ HIRAGINO KAKU G	/ PMINGLIU

o

ROMAJI

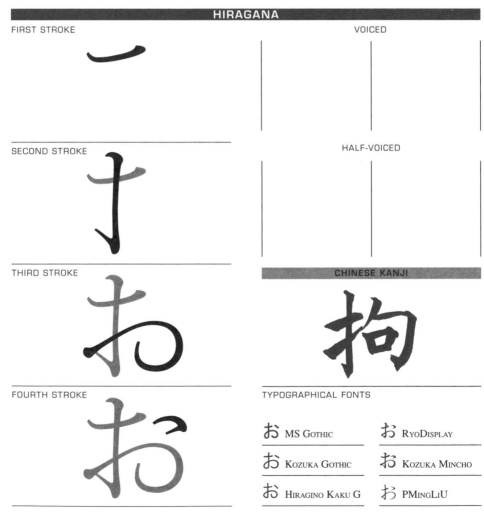

HIRAGANA

FIRST STROKE

VOICED

SECOND STROKE

HALF-VOICED

THIRD STROKE

CHINESE KANJI

FOURTH STROKE

TYPOGRAPHICAL FONTS

お MS GOTHIC

お RYODISPLAY

お KOZUKA GOTHIC

お KOZUKA MINCHO

お HIRAGINO KAKU G

お PMINGLIU

O

KATAKANA

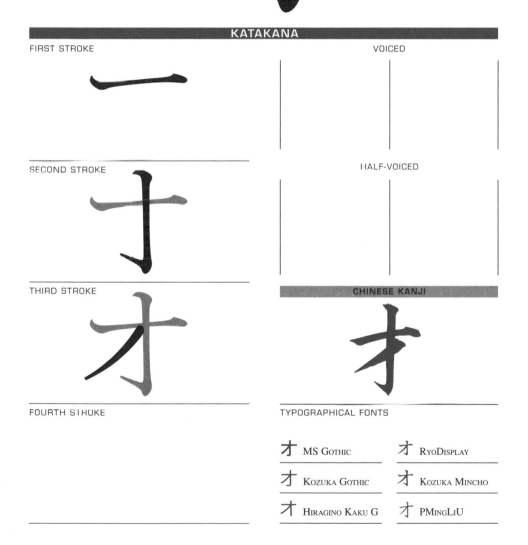

FIRST STROKE

VOICED

SECOND STROKE

HALF-VOICED

THIRD STROKE

CHINESE KANJI

FOURTH STROKE

TYPOGRAPHICAL FONTS

オ MS Gothic

オ RyoDisplay

オ Kozuka Gothic

オ Kozuka Mincho

オ Hiragino Kaku G

オ PMingLiU

ku

HIRAGANA

FIRST STROKE

VOICED: GU

SECOND STROKE

HALF-VOICED

THIRD STROKE

CHINESE KANJI

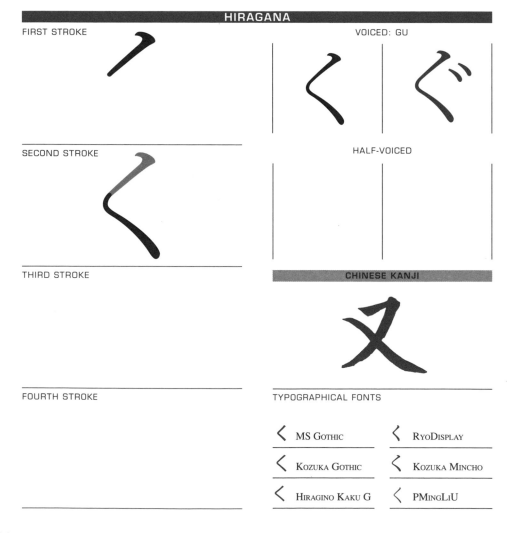

FOURTH STROKE

TYPOGRAPHICAL FONTS

〈 MS Gothic

〈 RyoDisplay

〈 Kozuka Gothic

〈 Kozuka Mincho

〈 Hiragino Kaku G

〈 PMingLiU

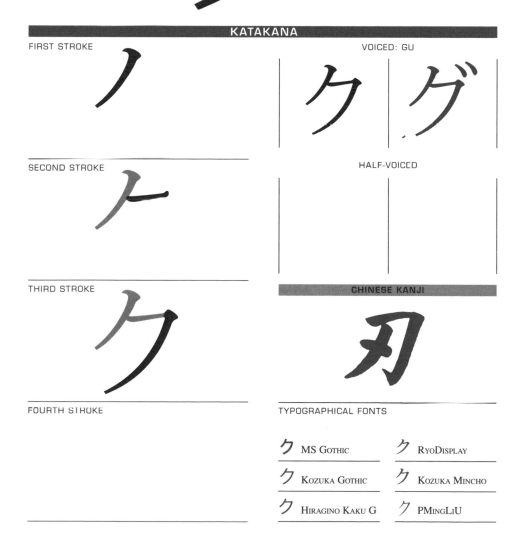

KATAKANA

FIRST STROKE

SECOND STROKE

THIRD STROKE

FOURTH STROKE

VOICED: GU

ク グ

HALF-VOICED

CHINESE KANJI

刃

TYPOGRAPHICAL FONTS

ク MS Gothic	ク RyoDisplay
ク Kozuka Gothic	ク Kozuka Mincho
ク Hiragino Kaku G	ク PMingLiU

103

HIRAGANA

FIRST STROKE

VOICED

SECOND STROKE

HALF-VOICED

THIRD STROKE

CHINESE KANJI

弔

FOURTH STROKE

TYPOGRAPHICAL FONTS

や MS GOTHIC

や RYODISPLAY

や KOZUKA GOTHIC

や KOZUKA MINCHO

や HIRAGINO KAKU G

や PMINGLIU

KATAKANA

FIRST STROKE

VOICED

SECOND STROKE

HALF-VOICED

THIRD STROKE

CHINESE KANJI

千

FOURTH STROKE

TYPOGRAPHICAL FONTS

ヤ MS Gothic	ヤ RyoDisplay	
ヤ Kozuka Gothic	ヤ Kozuka Mincho	
ヤ Hiragino Kaku G	ヤ PMingLiU	

HIRAGANA

FIRST STROKE

VOICED

SECOND STROKE

HALF-VOICED

THIRD STROKE

CHINESE KANJI

FOURTH STROKE

TYPOGRAPHICAL FONTS

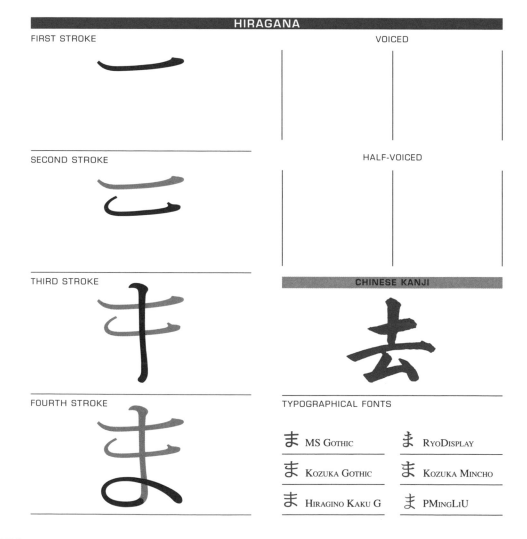

ま MS Gothic ま RyoDisplay

ま Kozuka Gothic ま Kozuka Mincho

ま Hiragino Kaku G ま PMingLiU

KATAKANA

FIRST STROKE

VOICED

SECOND STROKE

HALF-VOICED

THIRD STROKE

CHINESE KANJI

FOURTH STROKE

TYPOGRAPHICAL FONTS

マ	MS Gothic	マ	RyoDisplay
マ	Kozuka Gothic	マ	Kozuka Mincho
マ	Hiragino Kaku G	マ	PMingLiU

ke

ROMAJI

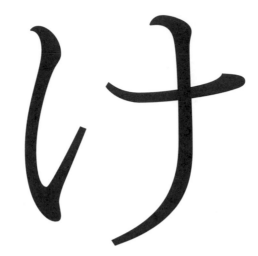

HIRAGANA

FIRST STROKE

VOICED: GE

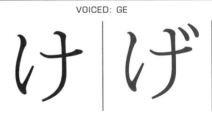

SECOND STROKE

HALF-VOICED

THIRD STROKE

KANJI CINESE

FOURTH STROKE

TYPOGRAPHICAL FONTS

け MS GOTHIC 　　け RYODISPLAY

け KOZUKA GOTHIC 　け KOZUKA MINCHO

け HIRAGINO KAKU G 　け PMINGLIU

108

ke

KATAKANA

FIRST STROKE

VOICED: GE

SECOND STROKE

HALF-VOICED

THIRD STROKE

CHINESE KANJI

FOURTH STROKE

TYPOGRAPHICAL FONTS

ケ MS GOTHIC

ケ RYODISPLAY

ケ KOZUKA GOTHIC

ケ KOZUKA MINCHO

ケ HIRAGINO KAKU G

ケ PMINGLIU

fu

ROMAJI

HIRAGANA

FIRST STROKE

VOICED: BU

SECOND STROKE

HALF-VOICED: PU

THIRD STROKE

CHINESE KANJI

与

FOURTH STROKE

TYPOGRAPHICAL FONTS

ふ MS GOTHIC ふ RYODISPLAY

ふ KOZUKA GOTHIC ふ KOZUKA MINCHO

ふ HIRAGINO KAKU G ふ PMINGLIU

110

KATAKANA

FIRST STROKE

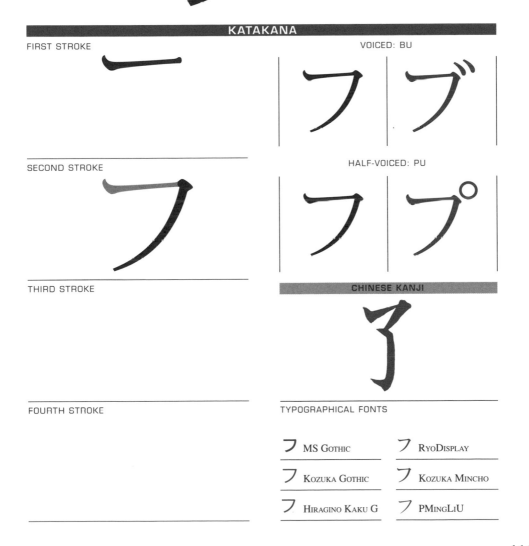

SECOND STROKE

THIRD STROKE

FOURTH STROKE

VOICED: BU

フ　ブ

HALF-VOICED: PU

フ　プ

CHINESE KANJI

了

TYPOGRAPHICAL FONTS

フ MS Gothic　　　　フ RyoDisplay

フ Kozuka Gothic　　フ Kozuka Mincho

フ Hiragino Kaku G　フ PMingLiU

ko

HIRAGANA

FIRST STROKE

VOICED: GO

SECOND STROKE

HALF-VOICED

THIRD STROKE

CHINESE KANJI

FOURTH STROKE

TYPOGRAPHICAL FONTS

こ MS GOTHIC

こ RYODISPLAY

こ KOZUKA GOTHIC

こ KOZUKA MINCHO

こ HIRAGINO KAKU G

こ PMINGLIU

KATAKANA

FIRST STROKE

VOICED: GO

コ ゴ

SECOND STROKE

HALF-VOICED

THIRD STROKE

CHINESE KANJI

四

FOURTH STROKE

TYPOGRAPHICAL FONTS

コ MS GOTHIC

コ RYODISPLAY

コ KOZUKA GOTHIC

コ KOZUKA MINCHO

コ HIRAGINO KAKU G

コ PMINGLIU

113

HIRAGANA

FIRST STROKE

VOICED

SECOND STROKE

HALF-VOICED

THIRD STROKE

CHINESE KANJI

FOURTH STROKE

TYPOGRAPHICAL FONTS

え	MS GOTHIC	え	RYODISPLAY
え	KOZUKA GOTHIC	え	KOZUKA MINCHO
え	HIRAGINO KAKU G	え	PMINGLIU

KATAKANA

FIRST STROKE

VOICED

SECOND STROKE

HALF VOICED

THIRD STROKE

CHINESE KANJI

FOURTH STROKE

TYPOGRAPHICAL FONTS

工 MS GOTHIC

工 RYODISPLAY

工 KOZUKA GOTHIC

工 KOZUKA MINCHO

工 HIRAGINO KAKU G

工 PMINGLIU

115

te

HIRAGANA

FIRST STROKE

VOICED: DE

SECOND STROKE

HALF-VOICED

THIRD STROKE

CHINESE KANJI

FOURTH STROKE

TYPOGRAPHICAL FONTS

て MS Gothic て RyoDisplay

て Kozuka Gothic て Kozuka Mincho

て Hiragino Kaku G て PMingLiU

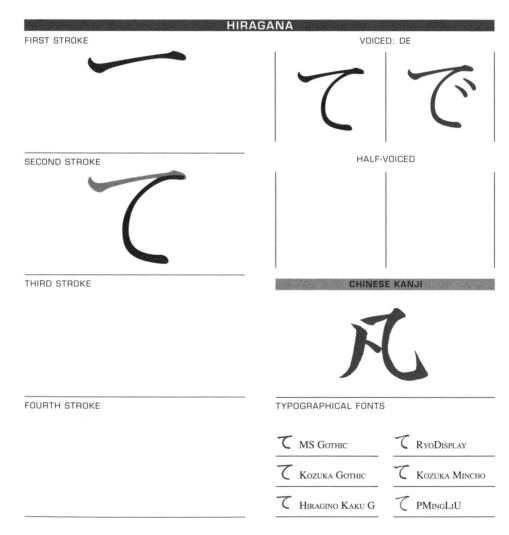

テ

KATAKANA

FIRST STROKE

VOICED: DE

テ　デ

SECOND STROKE

HALF-VOICED

THIRD STROKE

CHINESE KANJI

云

FOURTH STROKE

TYPOGRAPHICAL FONTS

テ MS GOTHIC

テ RYODISPLAY

テ KOZUKA GOTHIC

テ KOZUKA MINCHO

テ HIRAGINO KAKU G

テ PMINGLIU

HIRAGANA

FIRST STROKE

VOICED

SECOND STROKE

HALF-VOICED

THIRD STROKE

CHINESE KANJI

却

FOURTH STROKE

TYPOGRAPHICAL FONTS

あ MS GOTHIC	あ RYODISPLAY
あ KOZUKA GOTHIC	あ KOZUKA MINCHO
あ HIRAGINO KAKU G	あ PMINGLIU

KATAKANA

FIRST STROKE

VOICED

SECOND STROKE

HALF-VOICED

THIRD STROKE

CHINESE KANJI

FOURTH STROKE

TYPOGRAPHICAL FONTS

ア MS Gothic	ア RyoDisplay
ア Kozuka Gothic	ア Kozuka Mincho
ア Hiragino Kaku G	ア PMingLiU

sa

HIRAGANA

FIRST STROKE

VOICED: ZA

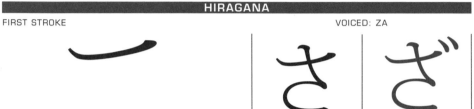

SECOND STROKE

HALF-VOICED

THIRD STROKE

CHINESE KANJI

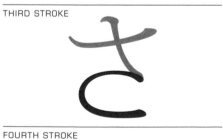

FOURTH STROKE

TYPOGRAPHICAL FONTS

さ	MS GOTHIC	さ	RYODISPLAY
さ	KOZUKA GOTHIC	さ	KOZUKA MINCHO
さ	HIRAGINO KAKU G	さ	PMINGLIU

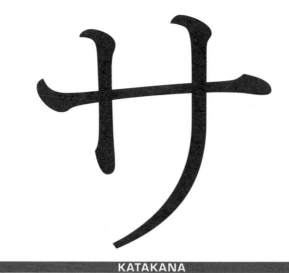

KATAKANA

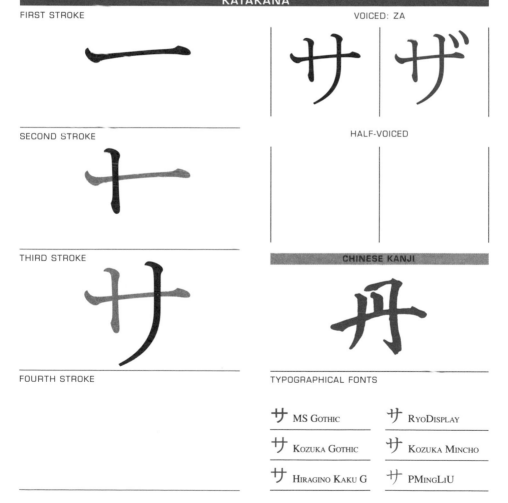

FIRST STROKE

VOICED: ZA

SECOND STROKE

HALF-VOICED

THIRD STROKE

CHINESE KANJI

FOURTH STROKE

TYPOGRAPHICAL FONTS

サ	MS Gothic	サ	RyoDisplay
サ	Kozuka Gothic	サ	Kozuka Mincho
サ	Hiragino Kaku G	サ	PMingLiU

ki

HIRAGANA

FIRST STROKE

SECOND STROKE

THIRD STROKE

FOURTH STROKE

VOICED: GI

き　ぎ

HALF-VOICED

CHINESE KANJI

吉

TYPOGRAPHICAL FONTS

き MS Gothic	き RyoDisplay
き Kozuka Gothic	き Kozuka Mincho
き Hiragino Kaku G	き PMingLiU

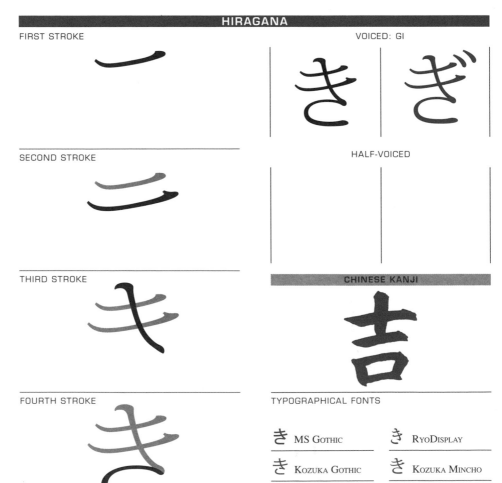

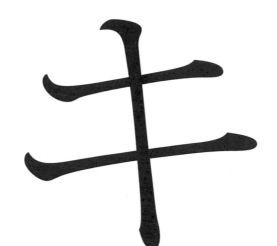

KATAKANA

FIRST STROKE

VOICED: GI

キ ギ

SECOND STROKE

HALF-VOICED

THIRD STROKE

CHINESE KANJI

中

FOURTH STROKE

TYPOGRAPHICAL FONTS

キ MS GOTHIC	キ RYODISPLAY
キ KOZUKA GOTHIC	キ KOZUKA MINCHO
キ HIRAGINO KAKU G	キ PMINGLIU

123

yu

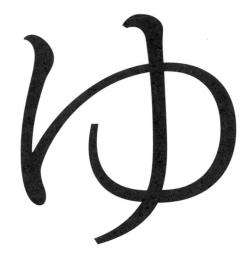

HIRAGANA

FIRST STROKE

VOICED

SECOND STROKE

HALF-VOICED

THIRD STROKE

CHINESE KANJI

功

FOURTH STROKE

TYPOGRAPHICAL FONTS

ゆ MS GOTHIC ゆ RYODISPLAY

ゆ KOZUKA GOTHIC ゆ KOZUKA MINCHO

ゆ HIRAGINO KAKU G ゆ PMINGLIU

KATAKANA

FIRST STROKE

VOICED

SECOND STROKE

HALF-VOICED

THIRD STROKE

CHINESE KANJI

FOURTH STROKE

TYPOGRAPHICAL FONTS

ユ MS Gothic	ユ RyoDisplay
ユ Kozuka Gothic	ユ Kozuka Mincho
ユ Hiragino Kaku G	ユ PMingLiU

me

ROMAJI

HIRAGANA	
FIRST STROKE	VOICED
SECOND STROKE	HALF-VOICED
THIRD STROKE	**CHINESE KANJI**
	女
FOURTH STROKE	TYPOGRAPHICAL FONTS

め MS GOTHIC め RYODISPLAY

め KOZUKA GOTHIC め KOZUKA MINCHO

め HIRAGINO KAKU G め PMINGLIU

me

KATAKANA

FIRST STROKE

VOICED

SECOND STROKE

HALF-VOICED

THIRD STROKE

CHINESE KANJI

FOURTH STROKE

TYPOGRAPHICAL FONTS

メ MS Gothic	メ RyoDisplay	
メ Kozuka Gothic	メ Kozuka Mincho	
メ Hiragino Kaku G	メ PMingLiU	

HIRAGANA

FIRST STROKE

VOICED

SECOND STROKE

HALF-VOICED

THIRD STROKE

CHINESE KANJI

升

FOURTH STROKE

TYPOGRAPHICAL FONTS

み MS GOTHIC

み RYODISPLAY

み KOZUKA GOTHIC

み KOZUKA MINCHO

み HIRAGINO KAKU G

み PMINGLIU

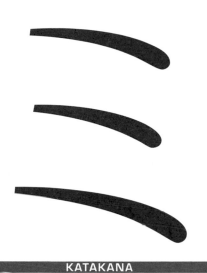

KATAKANA

FIRST STROKE

VOICED

SECOND STROKE

HALF-VOICED

THIRD STROKE

CHINESE KANJI

杉

FOURTH STROKE

TYPOGRAPHICAL FONTS

三	MS GOTHIC	三	RYODISPLAY
三	KOZUKA GOTHIC	三	KOZUKA MINCHO
三	HIRAGINO KAKU G	三	PMINGLIU

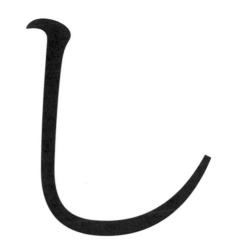

HIRAGANA

FIRST STROKE

VOICED: JI

SECOND STROKE

HALF-VOICED

THIRD STROKE

CHINESE KANJI

FOURTH STROKE

TYPOGRAPHICAL FONTS

し MS GOTHIC し RYODISPLAY

し KOZUKA GOTHIC し KOZUKA MINCHO

し HIRAGINO KAKU G し PMINGLIU

KATAKANA

FIRST STROKE

VOICED: JI

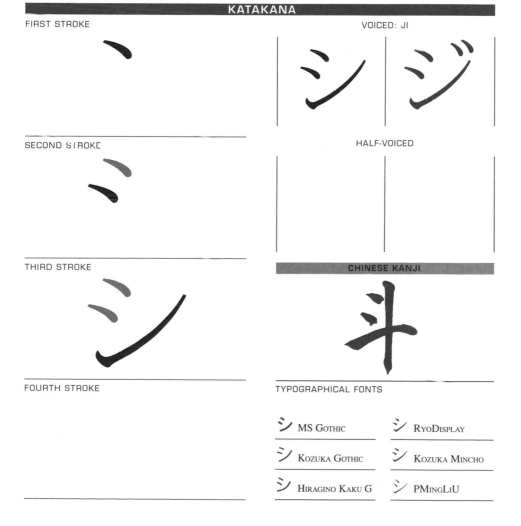

SECOND STROKE

HALF-VOICED

THIRD STROKE

CHINESE KANJI

FOURTH STROKE

TYPOGRAPHICAL FONTS

シ MS Gothic	シ RyoDisplay
シ Kozuka Gothic	シ Kozuka Mincho
シ Hiragino Kaku G	シ PMingLiU

HIRAGANA

FIRST STROKE	VOICED

SECOND STROKE	HALF-VOICED

THIRD STROKE	CHINESE KANJI

煮

FOURTH STROKE	TYPOGRAPHICAL FONTS

ゑ MS GOTHIC ゑ RYODISPLAY

ゑ KOZUKA GOTHIC ゑ KOZUKA MINCHO

ゑ HIRAGINO KAKU G ゑ PMINGLIU

KATAKANA

FIRST STROKE

VOICED

SECOND STROKE

HALF-VOICED

THIRD STROKE

CHINESE KANJI

互

FOURTH STROKE

TYPOGRAPHICAL FONTS

ヱ MS GOTHIC ヱ RYODISPLAY

ヱ KOZUKA GOTHIC ヱ KOZUKA MINCHO

ヱ HIRAGINO KAKU G ヱ PMINGLIU

hi

HIRAGANA

FIRST STROKE

VOICED: BI

SECOND STROKE

HALF-VOICED: PI

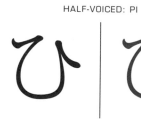

THIRD STROKE

CHINESE KANJI

FOURTH STROKE

TYPOGRAPHICAL FONTS

ひ MS Gothic ひ RyoDisplay

ひ Kozuka Gothic ひ Kozuka Mincho

ひ Hiragino Kaku G ひ PMingLiU

KATAKANA

FIRST STROKE

VOICED: BI

ヒ ビ

SECOND STROKE

HALF-VOICED: PI

ヒ ピ

THIRD STROKE

CHINESE KANJI

ヒ

匕

FOURTH STROKE

TYPOGRAPHICAL FONTS

ヒ MS GOTHIC ヒ RYODISPLAY

ヒ KOZUKA GOTHIC ヒ KOZUKA MINCHO

ヒ HIRAGINO KAKU G ヒ PMINGLIU

135

mo
ROMAJI

HIRAGANA

FIRST STROKE

VOICED

SECOND STROKE

HALF-VOICED

THIRD STROKE

CHINESE KANJI

FOURTH STROKE

TYPOGRAPHICAL FONTS

も MS GOTHIC

も RYODISPLAY

も KOZUKA GOTHIC

も KOZUKA MINCHO

も HIRAGINO KAKU G

も PMINGLIU

KATAKANA

FIRST STROKE

VOICED

SECOND STRUKE

HALF-VOICED

THIRD STROKE

CHINESE KANJI

FOURTH STROKE

TYPOGRAPHICAL FONTS

モ MS Gothic

モ RyoDisplay

モ Kozuka Gothic

モ Kozuka Mincho

モ Hiragino Kaku G

モ PMingLiU

HIRAGANA

FIRST STROKE

VOICED: ZE

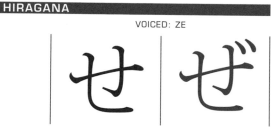

SECOND STROKE

HALF-VOICED

THIRD STROKE

CHINESE KANJI

FOURTH STROKE

TYPOGRAPHICAL FONTS

せ MS GOTHIC	せ RYODISPLAY
せ KOZUKA GOTHIC	せ KOZUKA MINCHO
せ HIRAGINO KAKU G	せ PMINGLIU

KATAKANA

FIRST STROKE

VOICED: ZE

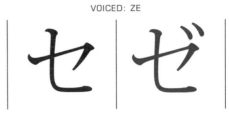

SECOND STROKE

HALF-VOICED

THIRD STROKE

CHINESE KANJI

FOURTH STROKE

TYPOGRAPHICAL FONTS

セ MS Gothic セ RyoDisplay

セ Kozuka Gothic セ Kozuka Mincho

セ Hiragino Kaku G セ PMingLiU

HIRAGANA

FIRST STROKE

VOICED: ZU

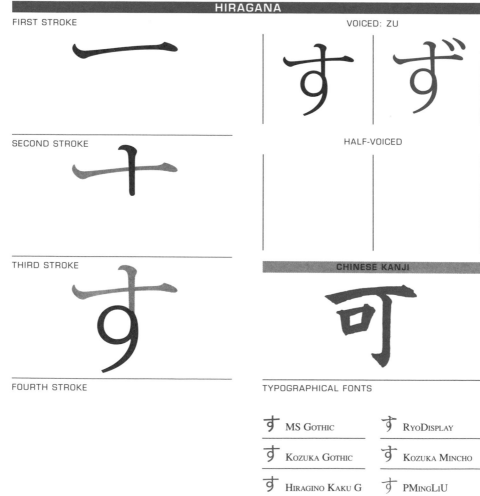

SECOND STROKE

HALF-VOICED

THIRD STROKE

CHINESE KANJI

可

FOURTH STROKE

TYPOGRAPHICAL FONTS

す MS GOTHIC す RYODISPLAY

す KOZUKA GOTHIC す KOZUKA MINCHO

す HIRAGINO KAKU G す PMINGLIU

KATAKANA

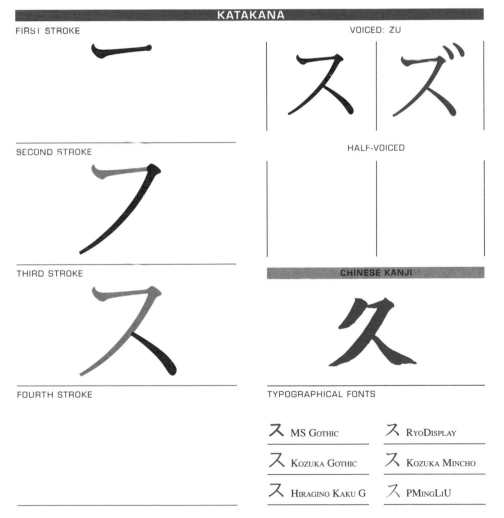

FIRST STROKE

VOICED: ZU

ス　ズ

SECOND STROKE

HALF-VOICED

THIRD STROKE

CHINESE KANJI

FOURTH STROKE

TYPOGRAPHICAL FONTS

ス MS Gothic	ス RyoDisplay
ス Kozuka Gothic	ス Kozuka Mincho
ス Hiragino Kaku G	ス PMingLiU

n

HIRAGANA

FIRST STROKE

VOICED

SECOND STROKE

HALF-VOICED

THIRD STROKE

CHINESE KANJI

人

FOURTH STROKE

TYPOGRAPHICAL FONTS

ん MS Gothic ん RyoDisplay

ん Kozuka Gothic ん Kozuka Mincho

ん Hiragino Kaku G ん PMingLiU

KATAKANA

FIRST STROKE

VOICED

SECOND STROKE

HALF-VUICED

THIRD STROKE

CHINESE KANJI

FOURTH STROKE

TYPOGRAPHICAL FONTS

ン MS Gothic

ン RyoDisplay

ン Kozuka Gothic

ン Kozuka Mincho

ン Hiragino Kaku G

ソ PMingLiU

143

INDEX